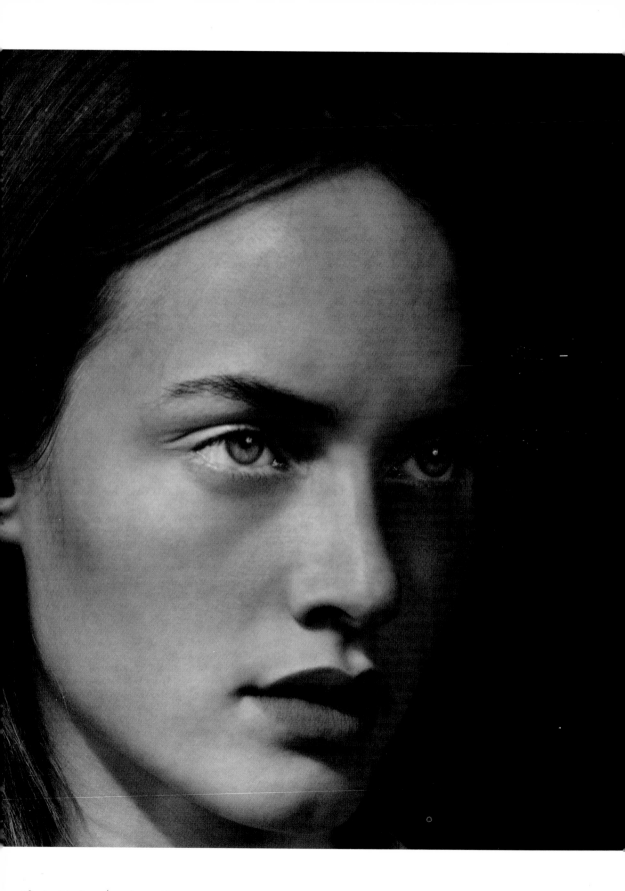

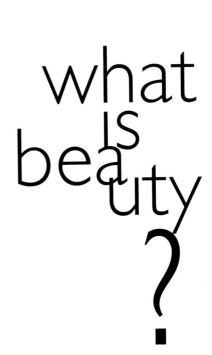

what is beauty ?

NEW DEFINITIONS FROM THE FASHION VANGUARD

BY DOROTHY SCHEFER

INTRODUCTION BY ISABELLA ROSSELLINI

FOREWORD BY BRUCE WEBER

DESIGNED BY SELECT COMMUNICATIONS

UNIVERSE PUBLISHING

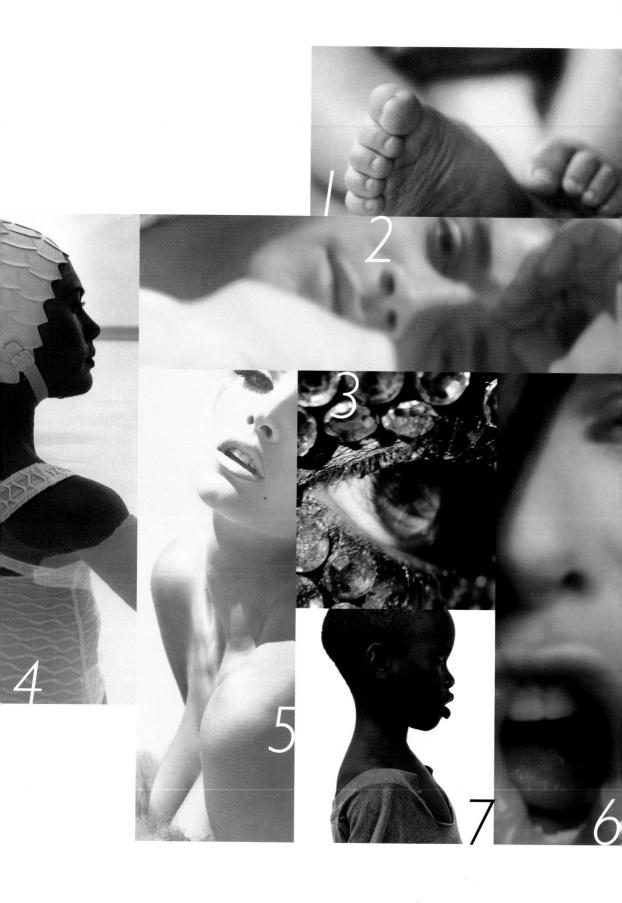

Contents

contributors

VISIONS AND VOICES

PROLOGUE

MICHEL COMTE
BARBARA KRUGER
PETER LINDBERGH
STEVEN MEISEL
FRANCESCO SCAVULLO
DAVID SIMS
BRUCE WEBER
text
DOROTHY SCHEFER
ISABELLA ROSSELLINI
BRUCE WEBER

INNOCENCE

PIERRE ET GILLES
KAREN KUEHN
PETER LINDBERGH
RICO PUHLMANN
PAOLO ROVERSI
PEGGY SIROTA
JEFFREY THURNHER
CHRISTIAN WITKIN
text
LINDA WELLS

LUST

RICHARD AVEDON
NAN GOLDIN
RUEDI HOFMANN
KURT MARKUS
JACK PIERSON
MICHAEL THOMPSON
ELLEN VON UNWERTH
TIMOTHY WHITE
BRUCE WEBER
text
BOB COLACELLO

ARTIFICE

DAVID JENSEN
KELLY KLEIN
STEVEN KLEIN
SERGE LUTENS
TONI MENEGUZZO
ANDREW MACPHERSON
FRANCESCA SORRENTI
TYEN
text
FRAN LEBOWITZ
AMY ASTLEY

acknowledgements

BOOKS
SUCH AS
THIS ARE
NEVER THE
WORK OF
ONE
PERSON
BUT A
TEAM…

...OUR EARTH ANGELS include: MARC PIPINO, founder and President of BeautyCares/HairCares, who had the dream...BRUCE WEBER, who was there from day one and never said no...STEVEN MEISEL and PETER LINDBERGH for their immediate and generous response... ISABELLA ROSSELLINI for embracing our cause and our project...HERWIG PREIS, our archangel, who underwrote part of this project, and his talented and dedicated team at Select Communications: ANGELA HALL, OLIVIER VAN DOORNE, AUBYN GWINN, PIERRE FURIA, who designed and art directed this book, JENNIFER ELSNER and DOUGLAS TOEWS...HARRIET WEINTRAUB and PROSPER ASSOULINE, who led us to our publisher, CHARLES MIERS, who gave this project his personal support, and our editor HEATHER KELLER, who kept it (and us) going...ANDREA MAURIO, our photo editor, who devoted full-time to this book and talked to over one hundred photographers...JUDITH NEWMAN, who, with her wisdom and humor, shaped the text...KAREN WILDER, of Wilder's Word Processing, who typed (and retyped) and faxed and e-mailed...DINA KEIDAN for wearing many hats beautifully and for crossing every "t" and VITTORIO ROBERTO for dotting the "i's"...JODI BALKAN, HOLLAND SWEET, CAROLINA RAUBER, JASMINE REDFERN, and DIANA BERMUDEZ for pitching in (as always) ...ASHER JASON, our friend, agent, and sage...ANDREW FINKELSTEIN for his valuable advice and support...LOU IACOVELLI, who carried the first pictures back from Paris...AMY ASTLEY, JUDSON BAKER, BRYAN BANTRY, HOLLY BRUBACH, RICHARD BUCKLEY, BOB COLACELLO, GRACE CODDINGTON, NANCY FRIDAY, JOHN GALLIANO, JEAN GODFREY-JUNE, AMY GROSS, MICHAEL GROSS, ANNEMARIE IVERSON, FRAN LEBOWITZ, BARBARA LIPPERT, INGRID SISCHY, LIZ TILBERIS, WILLIAM NORWICH, LINDA WELLS, and LESLIE WOLFE for picking up their phones...and all the photographers, designers, editors, stylists, models, writers, hair and makeup people, their agents and assistants who **MADE THIS BOOK POSSIBLE** simply by saying "Yes."

DOROTHY SCHEFER

beauty is... BY DOROTHY SCHEFER

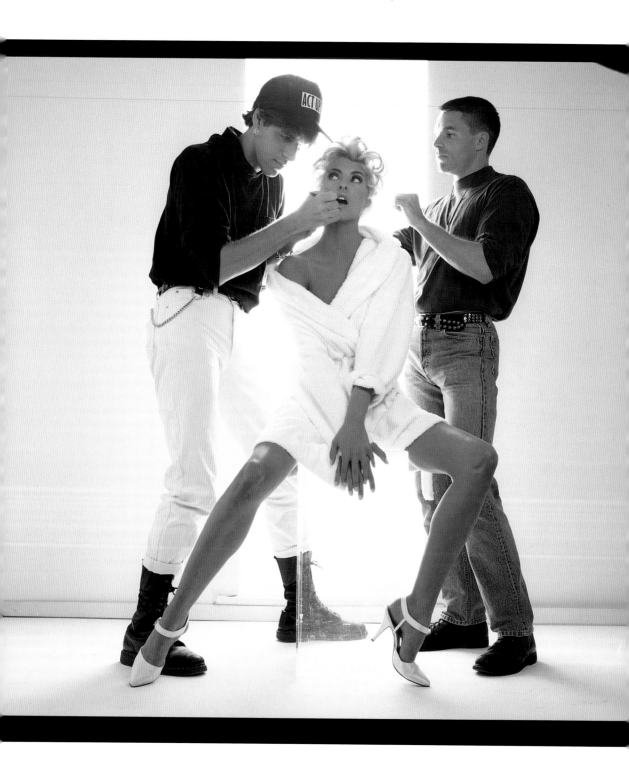

TO
ASK
WHAT
IS
BEAUTY

today is to come face to face with the changing definition of beauty. Perhaps more than any other time in history, we are preoccupied with, even confused by beauty: its power, its pleasures, its style, and its substance. Beauty may not be the most important of our values, but it affects us all; today more than ever, because we live in a Media Age where our visual landscape changes in seconds, and our first reaction to people is sometimes our last. Given this reality, the so-called "triviality" of beauty suddenly seems not so trivial after all.

The beauty we see today is different, more complex. It's elusive, evolutionary, even controversial. No longer is beauty limited to a pretty face or a pretty picture: beauty has come to personify and reflect the social and cultural issues of our day.

By going behind the scenes and inside the image industry, my goal was to explore this phenomenon and create a thought-provoking record of our time. I offered the image makers who shape the way we look a forum to answer the question: What is beauty? I asked the most influential fashion photographers working today to submit visions which reflect their changing definitions of beauty. And I invited taste-makers on the cutting edge—fashion designers, hairstylists, makeup pros, and stylists—to interpret the new beauty; I also included the voices of fashion muses and visionaries ranging from Coco Chanel to Martha Graham, whose avant-garde ideas still influence today's styles. I challenged today's leading fashion journalists, editors and trenchant commentators on culture to translate confusing messages and to give perspective to extreme images.

In the process of arriving at a definition, the image makers wrestled with an extraordinary variety of issues. Heroin chic, for example, was at first brushed off as a retro look, destined to vanish quickly as most trends do. No one could have predicted the widespread and mainstream adoption of this look by a new generation. Many explanations have been given. Fashion critic Richard Buckley attributes heroin chic to a reaction against 80s consumerism. Interview editor Ingrid Sischy sees it as a way for our culture to make beauty more inclusive. Although the future of post-modern beauty embodies unglamorized realism, artifice and cosmetic surgery are on the increase. Fran Lebowitz explains why glamour will always be expected of women in our society. Michael Gross argues that there is a changing ideal of women based on real and expanding definitions. Other trend-driven issues addressed by our contributors: Has androgyny become the new beauty ideal? Why have supermodels replaced actresses in the glamour pantheon? When did attitude

replace elegance? Anorexia and body dysmorphia are rampant: will the pendulum in fashion ever swing back to an appreciation of real women's bodies? Often, when people see images of models, instead of feeling appreciated or inspired, they end up feeling bad about themselves. They feel they can't measure up to the unattainable ideals they see: ideals that owe a great deal to makeup artists, perfect lighting, and air-brushing.

As we move toward the millennium, one of the questions we must ask ourselves is: when will beauty no longer be defined by media-promoted and commodified images—flawless features, flawless figures, without regard to what's underneath the surface? Today, we want images of beauty to be more realistic and to acknowledge the attractiveness of our power, our intelligence and our experience. The battle to integrate surface with substance, to assert that beauty should be tied to who we are rather than to our body weight or to the firmness of our skin, has changed us forever. In today's quest for a self-celebrating image, we are finally beginning to have a broader and more positive view of what beauty can include. We're beginning to take more risks, to experiment with our appearance, and not be constrained by the images we see in magazines and on billboards.

Ultimately, fashion's contribution to social change can be seen on the runway in the "new" beauty. Grunge and deconstructivism were only the beginning; the movement away from 80s materialistic ideals of artifice and power dressing—big shoulders, big jewelry, bright makeup, big hair—was taken even further with the "waif" look. Now, as our culture narrows the gender gap, it is no surprise that androgyny is becoming a mainstream ideal, and interest in male beauty is growing. The move to a multicultural nation has given rise to a more inclusive beauty, a beauty that celebrates new faces. The broadening definition also allows for entirely new categories, such as "ugly beauty"—the street-inspired extreme of the 90s. Today, beauty takes its cue from fashion, and fashion's new direction is pared down: less contrived, relaxed, and more honest. As you read this book, consider this: you are not just exploring beauty. You are looking at its future.

However we try to define beauty for ourselves, we are still bombarded by media images vying for our attention. The best of these images speak not just to our wallets, but to our minds: they demand that we question society's notions about appearance, look at our changing visual culture and reexamine our own attitudes and

IDEAS
ABOUT
BEAUTY.

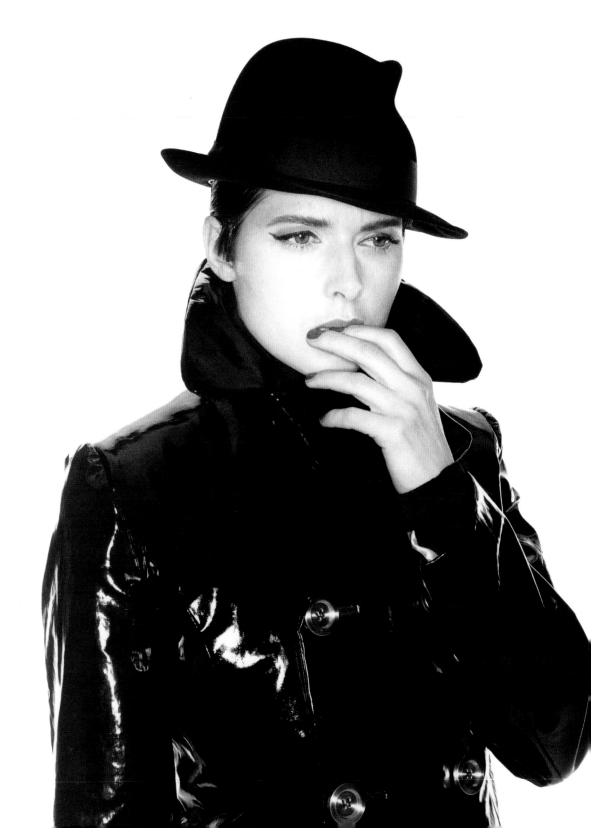

introduction BY ISABELLA ROSSELLIN

And what is its greatest drawback?

There is no drawback to being recognized as a beauty. Beauty in a woman is a powerful weapon. But my mother, Ingrid Bergman, taught me the value of being matter-of-fact about the subject. When people said to her, "You are so beautiful," she was embarrassed and never knew what to answer. Finally, she came up with what she thought was the perfect reply: "Isn't it lucky!" And I agree with her—that's just the right attitude.

You've often said we live in an ageist and "looksist" society? Where do you think this prejudice comes from?

I don't know where it comes from. I just know it's there. You can't open a women's magazine and see a photograph of a forty-year-old woman unless she has an Academy Award nomination. Never is anybody who's unusual-looking celebrated as a definition of beauty. There's very little room for black, Asian, or mixed-race models. I am just stating a fact. I don't know why we narrow the definition of beauty so much that we are all reduced to having complexes and feeling inadequate.

What do you see as a positive aspect of beauty in our society?

I am interested in cosmetics, beauty, and fashion as vehicles for play. Applying makeup and dressing up are part of the entertainment world, like films, circuses and amusement parks. They allow a woman to create a persona to present to the world. It's like having a little armor that provides a chance to connect with people while still protecting one's inner self.

What is your definition of beauty?

Well, style is more interesting to me than beauty. Style is about panache, and about embracing individuality. I always think of a story that Joel Schumacher, director of *St. Elmo's Fire* and *Batman Forever*, told me about *Vogue* editor Diana Vreeland, during the days he worked in fashion. Joel always felt that he had a very long nose, so he grew a beard to compensate for it. Diana Vreeland said "Wrong! You have to assume your nose." And that is style. That's what beauty is about for me—celebrating

UNIQUENESS NOT CONFORMITY.

foreword by Bruce Weber

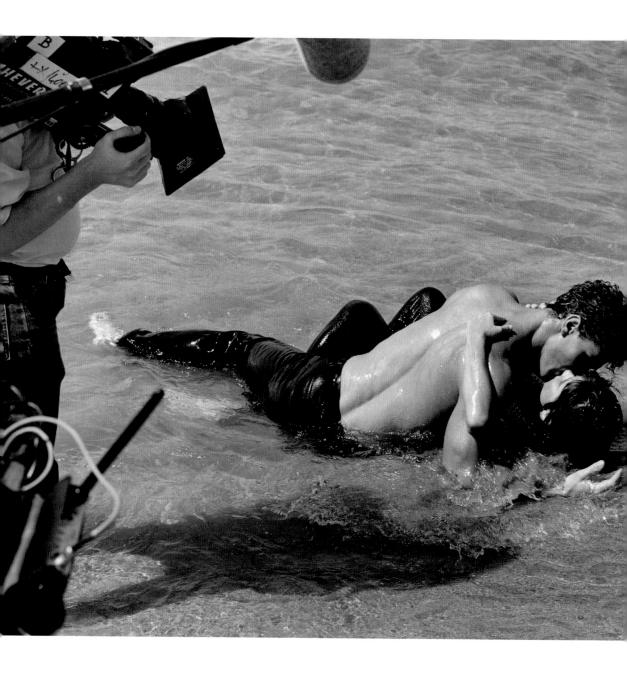

I sometimes say, "Who cares?" It's raining and a friend is driving me to another location, and the idea of writing makes me want to curl up like a baby and listen to Doris Day sing me a lullaby. I was asked to write about a certain kind of beauty, but that's impossible because my idea of beauty hopefully changes every two minutes. When I had my first studio, about as big as a stall for a pony, I had the great luck of working with the talented hairdresser BOB FINK. All he had was a pair of scissors and a broken black Ace comb. I used to say, "Bob, wouldn't it be great to give this guy a football/summer camp haircut?" And he would reply, "Who cares?" Bob would sometimes let people cut their own hair, because they knew their hair better than anyone else. It was frustrating; but he taught me that it's best sometimes to let things in life remain as you find them. In those days, when I was lucky once in a blue moon to have someone ask me to take photographs, I got to work with VINCENT NASSO, whose makeup transformed everyone. The art director would always try to intimidate you and your team—because we were all beginners—and interrupt the process of taking a photograph. One day, I was so nervous I arrived at my studio leaving my cameras at home. But Vincent, who looked like a handsome high school wrestling champion, would put his hands on his hips and say to the art director, who was hunched over in the corner of the studio: "Listen, doll, stop worrying; we're not exactly doing heart surgery here. I think she looks R-E-A-L pretty!" Vincent's best friend was DIVINE. But what was divine about Vincent was that besides doing beautiful makeup, he taught all of us to never be afraid of having an "attitude" about something worth fighting for.

I started photographing college girls and surfers

because, when you begin to take photographs, it is difficult to get anyone to pose for you for so little money. I would go on location with the makeup artist LITTLE MARK (we called him that because he was short and looked like a poet in his tortoiseshell glasses), and the hairdresser MARC PIPINO, who was as tall as a basketball player from the NBA. Little Mark's shyness and sincerity made people who weren't used to being in front of a camera trust him. Years later, Little Mark had become ill with AIDS, but he was still trying to work. One day, Little Mark was working at another studio for a cosmetics company. As he started applying a cream to the model's face, she excused herself and went to another room to talk to the creative director from the advertising agency. When she didn't return, Little Mark wondered what was wrong. Someone from the agency came into the dressing room and told him he had to leave because he was ill and that the model didn't want him to touch her. He quietly packed his lipsticks, creams, and brushes. He walked out of the studio and everyone looked down at the floor and didn't say a word. Little Mark died shortly after that, and when I think of that happening to him, I wish Bruce Lee could have practiced some karate kicks at those people, so something like this would never happen again.

No, I can't describe beauty. But I can describe friends who came into my life like a thunderstorm over the mountains and helped me simply to do what I love most to do—take photographs. Just like newborn pups, all of our friends—ill or healthy—sometimes need a helping hand or a big hug. I know that Bob, Vincent, and Little Mark are looking down on me and laughing because I'm taking myself so seriously by writing the foreword for this book. When I was first asked, I thought, "Who cares?" But as I wrote this in the car on a rainy day on my way to another location, I started missing my friends and I realized, "I care."

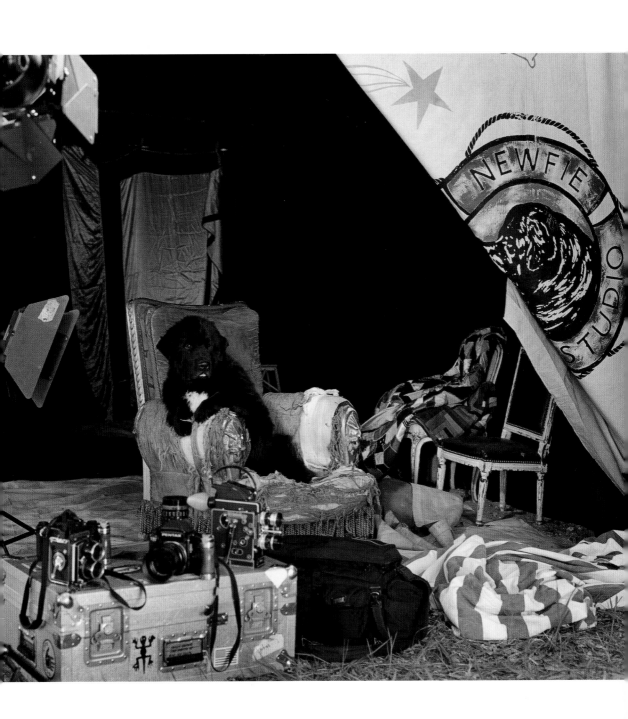

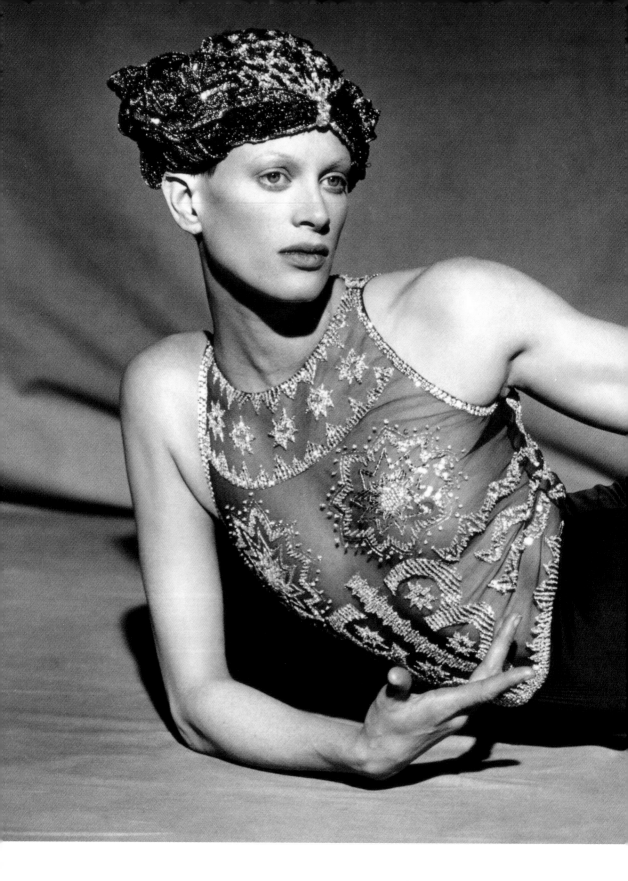

18 peter lindbergh / *kristen mcmenamy "homage to diaghilev" studio one nyc 1992*

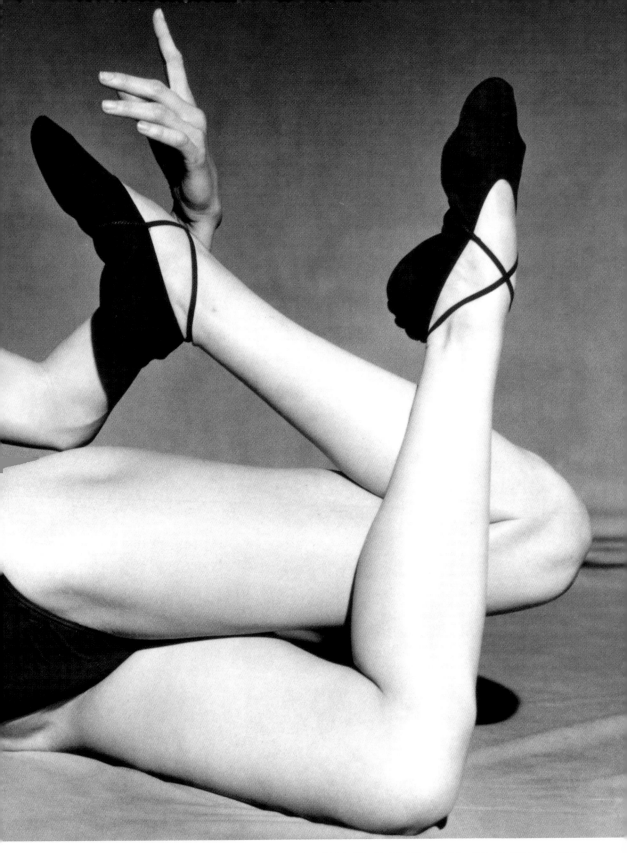

THE IDEA THAT BEAUTY IS UNIMPORTANT IS THE REAL BEAUTY MYTH.

nancy etcoff

(OOH) BABY LOVE

BY LINDA WELLS

I am pushing a stroller down the street and this is what happens. My son, eighteen months old, legs whirling with glee, is drawing crowds. He is the stereotype of a cherub: chubby cheeks, big wide blue eyes, Cupid's-bow lips, golden hair with a fluff of curls in back. It's as if one of those Italian frescoes came to life and landed in a stroller in the late twentieth century.

People stop and point. They stand still, elbow each other and laugh. Their faces soften, they lean down and speak gibberish. They pinch him.

He is innocence made flesh. And that is irresistible. In wanting to touch him, people seem to want to get a little piece of goodness.

Studies have revealed that babies are made to be cute so that their parents will be seduced into caring for them. As babies become children, then teenagers, and then adults, they lose the innocence and the look (sorry).

But they don't lose it without a fight. Women rub on circles of blush, color their hair, curl and mascara their eyelashes, and line their lips to imitate exactly what came naturally as babies. Sometimes it works.

Look at Audrey Hepburn. Those great big eyes, that soft, astonished voice were childlike virtues in an adult body. Princess Diana perfected the look of naiveté by bowing her head and gazing up at the paparazzi. Now, we know she's no innocent, but we're charmed anyway.

Sometimes it doesn't work. Look at Bette Davis as Baby Jane. She wore little pigtails and a party dress and shoved Joan Crawford around in a wheelchair. That's not nice, Baby Jane.

My husband tells me that his favorite look for a woman is fresh from the shower in a T-shirt and jeans. I agree entirely. And I would gladly comply, I really would. Except that I need a blow-dryer, hair gel, round brush, concealer cream, eyelash curler, mascara, brow pencil, blusher, and lip gloss. I am, I admit, no innocent.

IN THE DIFFICULT AND WONDERFUL BATTLE OF LIFE, THE SIMPLE WOMAN EMERGES VICTORIOUS, THE SOPHISTICATED ONE, DEFEATED.

coco chanel
1883 - 1971

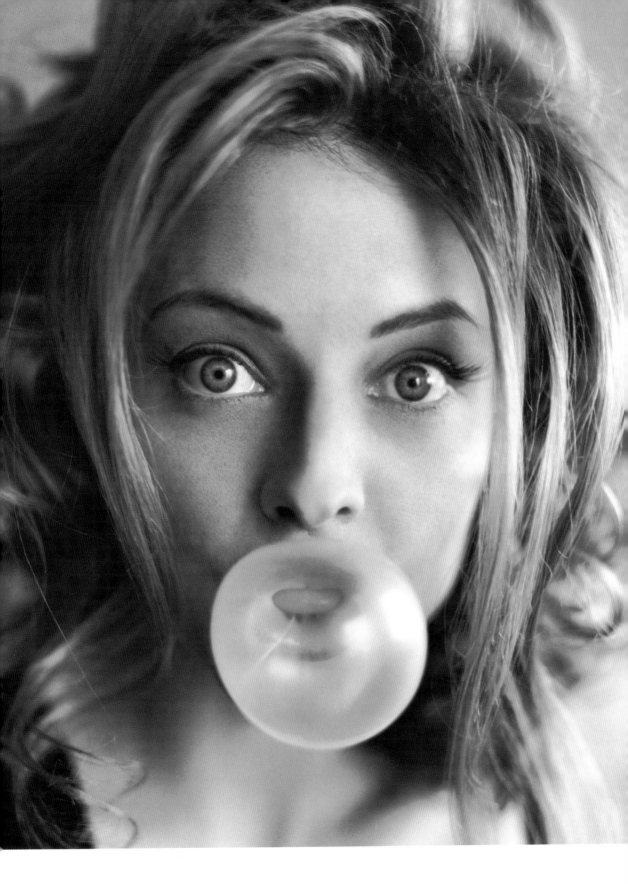

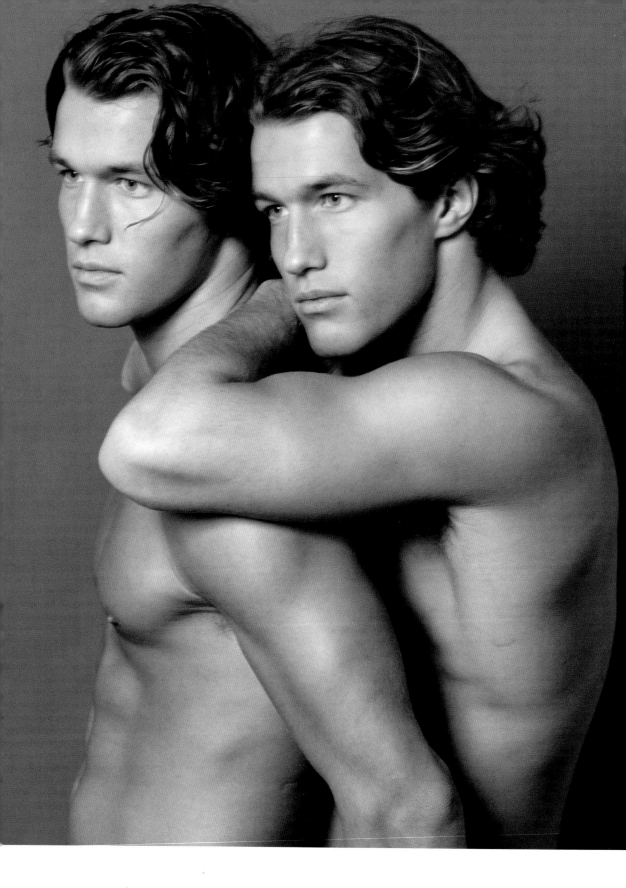

WITHOUT e m o t i o n, THERE IS NO BEAUTY. *diana vreeland 1902-1982*

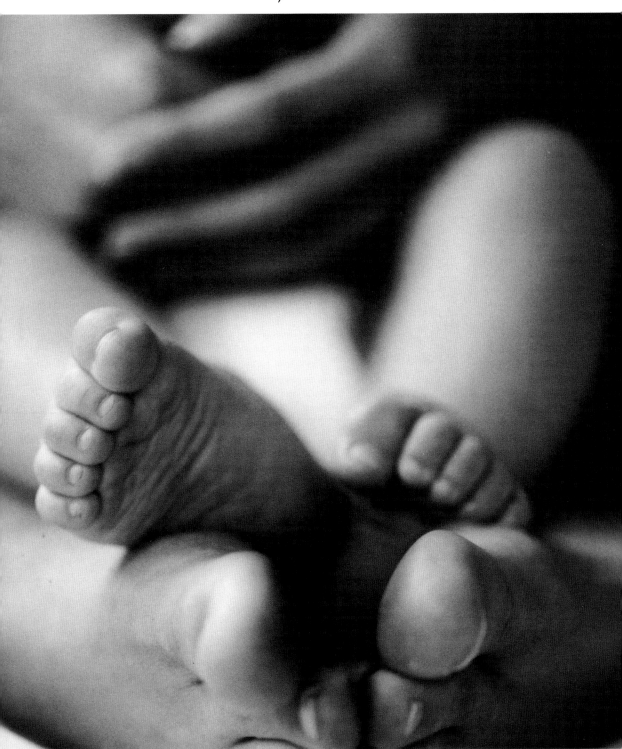

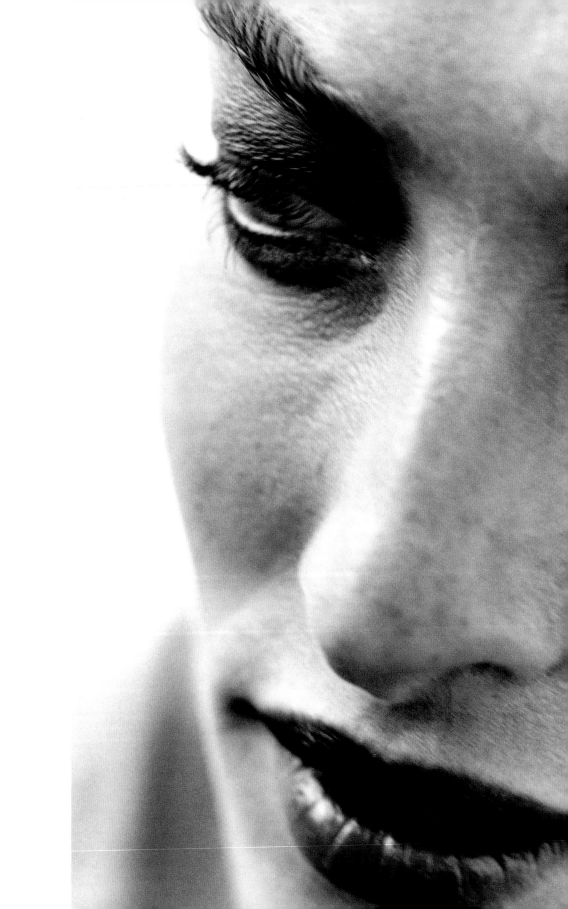

BEAUTY IS SOMETHING VERY PERSONAL that you sense and respond to on a deep level. It's hard to define, but when you see it, you feel it very strongly and are moved by it. The beauty I love is in people who look real. A BEAUTY THAT IS PURE, NATURAL, AND NOT GLAMORIZED.

calvin klein

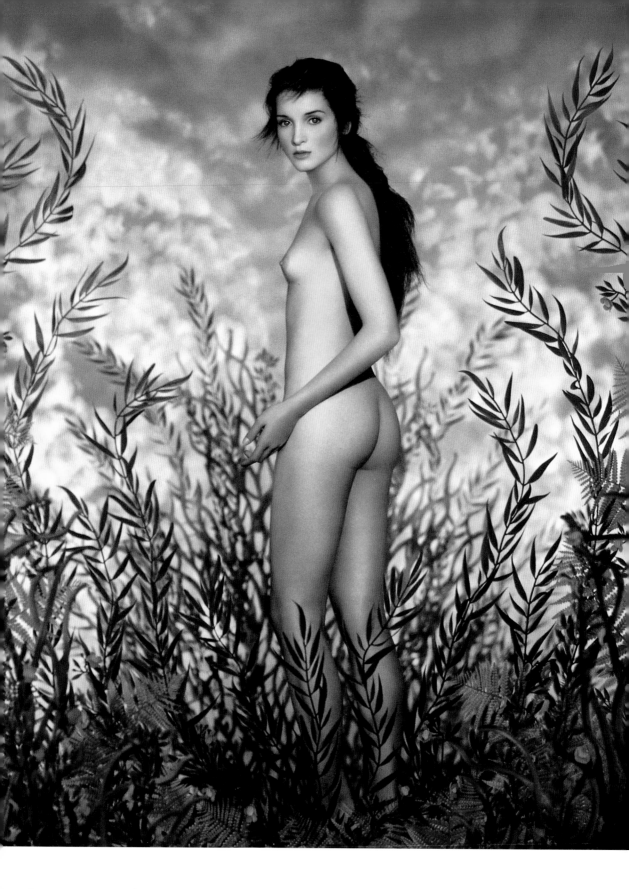

I GREW UP IN A SMALL TOWN IN THE MIDWEST and relatives back east were always sending us fabric—they thought we were pioneers or something and had to sew our own clothes. As far as sewing went, my mother could take it or leave it, but I was hooked. One day, when I was seven, my relatives sent a material so ugly, my mother just handed it over to me and said, "Here, dear, you make something out of it."

It was brown with a giant paisley on a nice cotton sateen. I made a two-piece ensemble with a clothesline in the waist to hold it together. I saw a picture of myself in this dress recently, and when I tell you it was so ugly, it's scary, I'm not exaggerating. But I felt like a princess in that dress. I wore it every single day for a whole summer. I had it all accessorized, with giant bows in my hair. My mother couldn't get me to take it off.

Now, when I see people dressed up, I just hope they feel as good as I felt in that dress. When I wore that thing, I was on fire.

cynthia rowley

TO THIS DAY, WHENEVER I SEE LILACS, I'M OVERCOME. GROWING UP IN MY HOME, WE HAD HUGE BUSHES OF THEM. MY BROTHERS AND I WOULD DIVE INTO THEM AND PLAY, AND IT WAS GLORIOUS TO BE SURROUNDED BY THE SMELL. BUT LILACS ONLY BLOOM FOR ABOUT TWO WEEKS. THERE WAS SUCH A SHORT SEASON TO ENJOY THEM. IT'S THAT COMBINATION OF LUSHNESS AND TRANSIENCE that always defined beauty for me.

amy astley

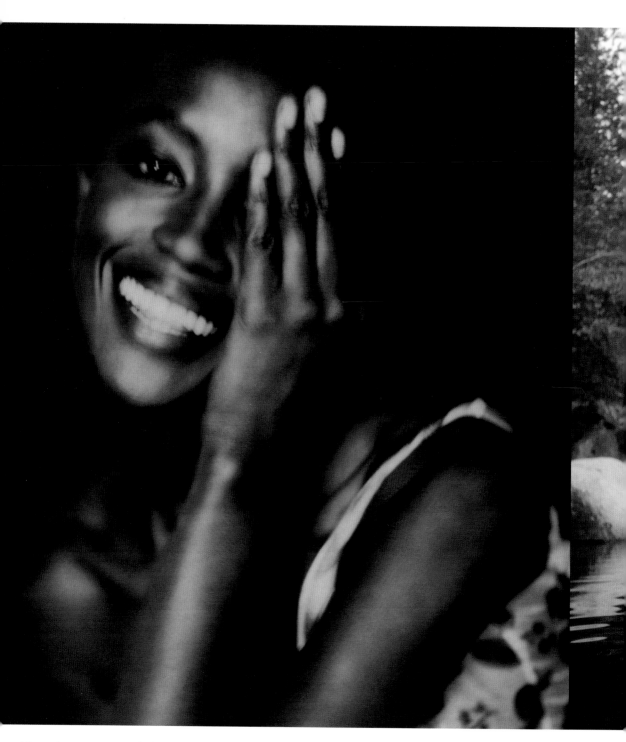

if you're not one of the goddesses, that stuff about not being good enough can last a lifetime.

helen gurley brown

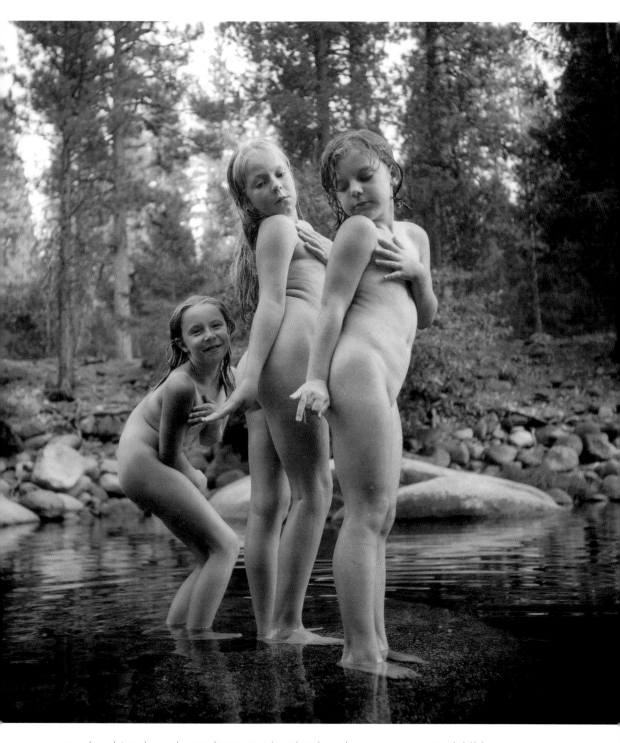

my daughter has always been my inspiration, but now my grandchildren are
starting to inspire me. mckenzie is always telling me she has to have a tube skirt and it
has to be *this* tight... at eight
she's a
fashion
critic. *donna karan*

31 karen kuehn / *amy, kelly, and tracy erickson "water giggles"*

the
things
which
the
child
loves
remain
in
the
domain
of
the
heart
until
old
age.
the
most
beautiful
thing
in
life
is
that
our
souls
remain
hovering
over
the
places
where
we
once
enjoyed
ourselves.

khalil gibran
1883-1931

YOU
CAN
IGNORE
40
YEARS.
YOU'RE
YOUNG,
YOU
STILL
FEEL
YOUNG.
AND
50
YEARS
IS
AN
IMPORTANT
MATURITY
POINT.
BUT
60
IS
THE
RIGHT
TURNING
POINT
TO
CHANGE
SOMETHING
IN
YOUR
LIFE,
TO
REDO
YOUR
PSYCHOLOGICAL
MAQUILLAGE.

giorgio armani

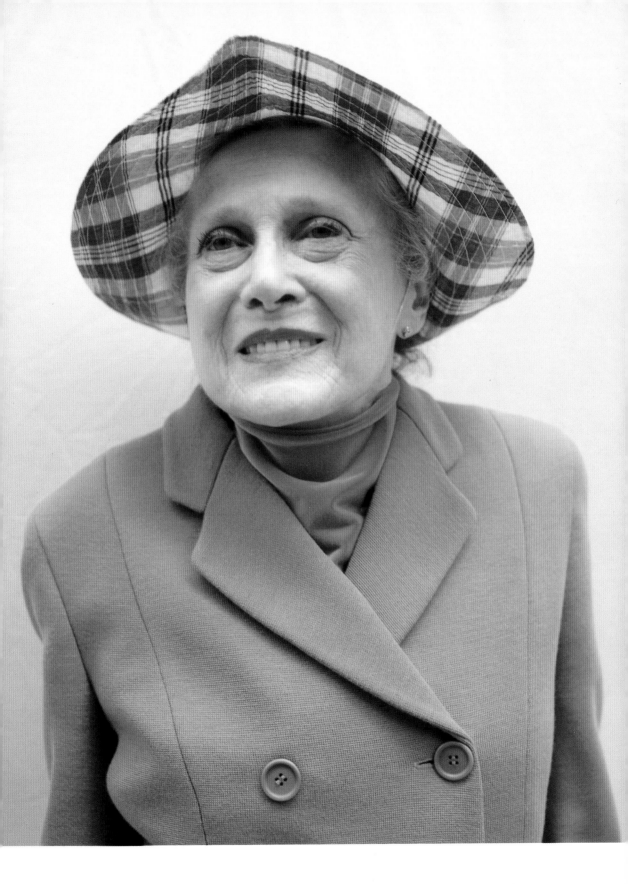

THE
TYRANNY
OF
DESIRE

BY BOB COLACELLO

"Beauty is the hardest drug of all"…I wrote in a 1971 issue of *Interview* magazine devoted to Luchino Visconti's film of Thomas Mann's *Death in Venice*. I'd been addicted to beauty ever since I saw Lana Turner in *By Love Possessed*. (Or was it Elvis in *Love Me Tender?*) Later, Botticelli's *Venus* and *St. Sebastian* competed for the center of attention in my teenage dreams.

When I went to work at The Factory in 1970, I realized that Andy Warhol was one of the biggest beauty junkies of our time. Andy divided people into "beauties" and "talkers." If you weren't the former, you had better be the latter to last around him. The reigning Factory beauties then were the muscular Joe Dallesandro and Candy Darling, the blonde transvestite who took great pride in a *New York Times* review that called her a cross between Kim Novak and Pat Nixon. I was definitely a talker.

Many of Warhol's famous friends, including Mick and Bianca Jagger, Yves Saint Laurent, Halston, and Nureyev, were also hooked on beauty—their own and other people's. Peter Beard, who photographed several early *Interview* covers, liked to say that beauty was most beautiful when it was in danger—Iman clinging to a cliff in Montauk, for example, or Veruschka tied to a Kenyan tree. Only Truman Capote, among this crowd,

found beauties boring. He preferred middle-aged Irishmen with big bellies and big families—so he would always be the beauty.

It's not true, as kids seem to think today, that people were more beautiful or the times more glamorous in the 70s. At the time, we longed for the style and stars of the 30s and 40s—Garbo, Dietrich, Gary Cooper, Errol Flynn,

Diana Vreeland, who had seen it all, always insisted that the first requirement of beauty was cleanliness, and Andy, who feared germs almost as much as going broke, heartily agreed. Of course, there are artists and photographers who can make anyone they portray look beautiful.

But beauty is not in the eye of the beholder; although it is sometimes in the mind of the beauty. It is a real thing, based on visible qualities of line, form, light, proportion and grace. It goes without saying that it is a gift from on high. Worshipping it too much, however, can verge on the sacrilegious. And addicts of beauties have been known to overdose on expensive models, or cosmetic surgery, or—like Dirk Bogarde in *Death in Venice*—unrequited love.

SEX
AND
BEAUTY
ARE
INSEPARABLE,
LIKE
LIFE
AND
CONSCIOUSNESS...

d.h. lawrence
1885-1930

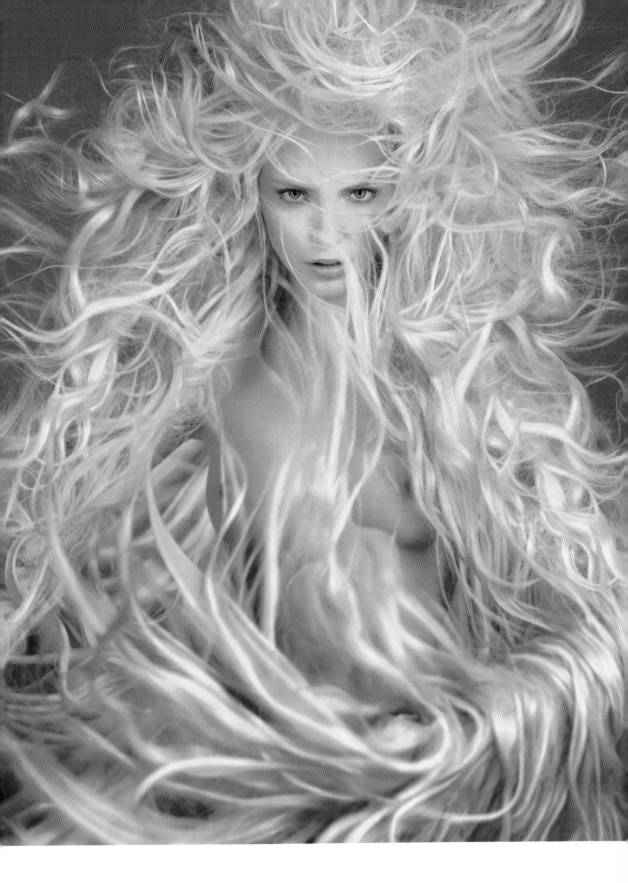

photographed by richard avedon / *nadja auermann, 1995 pirelli calendar*

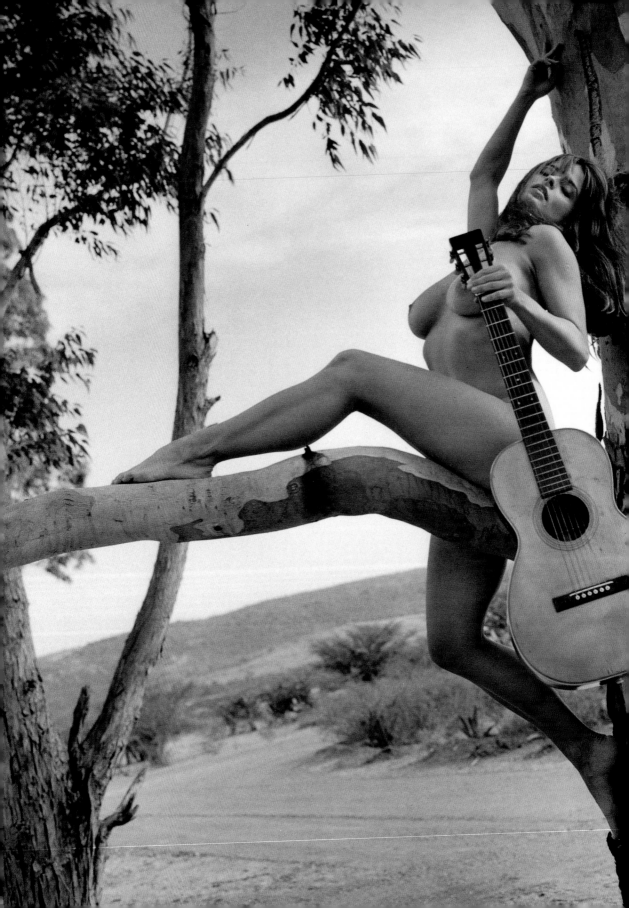

BEAUTY
ISN'T
SOMETHING
THAT
PLEASES
THE
EYE, BUT IN SOME MANNER TOUCHES
THE SOUL. THE FIRST TIME I EXPERIENCED BEAUTY
I WAS TAKEN TO YANKEE STADIUM FOR THE FIRST
TIME. IT WAS THE MOST STUNNING PLACE I HAD
EVER SEEN. I'D NEVER SEEN THAT COLOR GREEN
ANYWHERE. I REMEMBER EVERYTHING ABOUT THE
DAY. THE YANKEES WON, 6-3.

A GUY NEVER FORGETS THE FIRST GIRL HE KISSES,
THE FIRST GIRL HE HAS SEX WITH, AND HIS FIRST
BASEBALL GAME.

art cooper

MEN'S
IDEAS
OF
BEAUTY
ARE
FOREVER
ROOTED
IN
HIGH
SCHOOL.

fran lebowitz

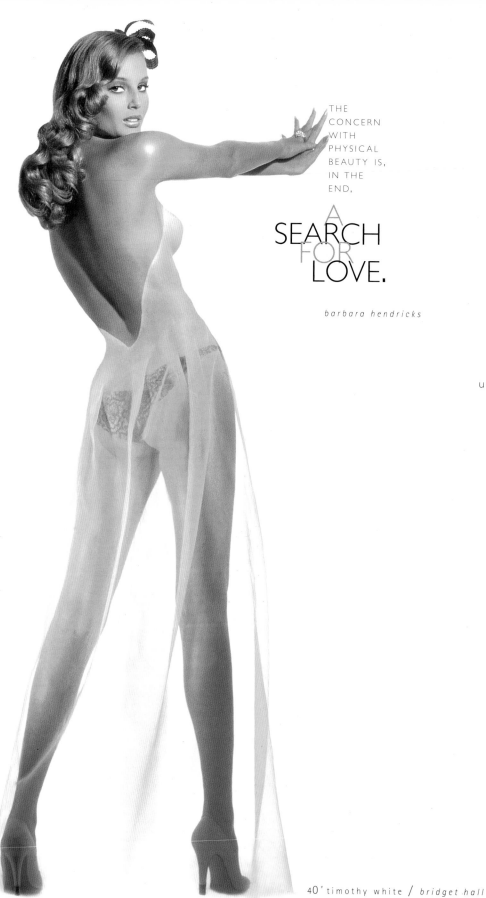

THE
CONCERN
WITH
PHYSICAL
BEAUTY IS,
IN THE
END,

A
SEARCH
FOR
LOVE.

barbara hendricks

a
pursuit
so
ardent,
so
passionate,
so
risk-filled,
so
unquenchable
reflects
the
workings
of
a
basic
instinct.
to
tell
people
not
to
take
pleasure
in
beauty
is
like
telling
them
to
stop
enjoying
food
or
sex
or
love...

nancy etcoff

40 *timothy white / bridget hall*

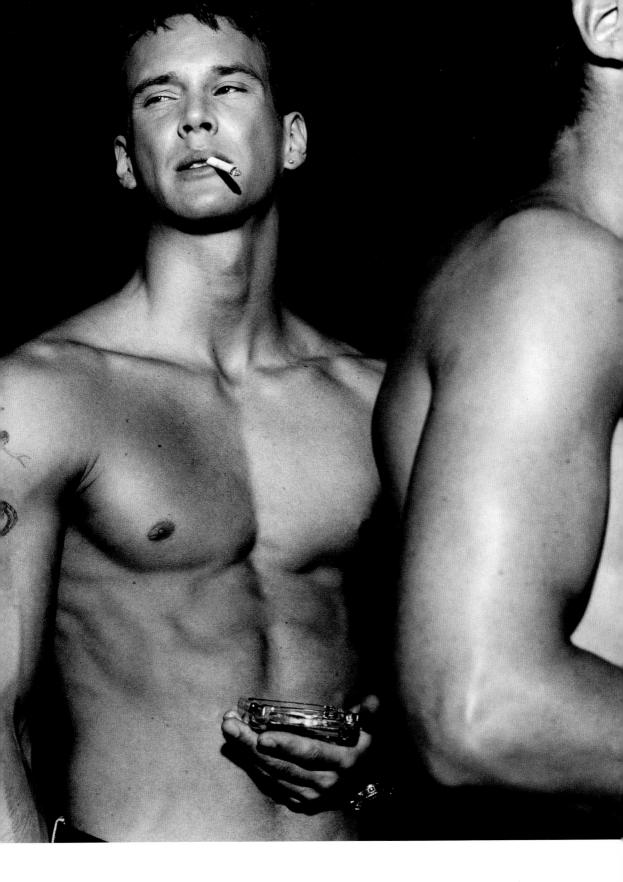

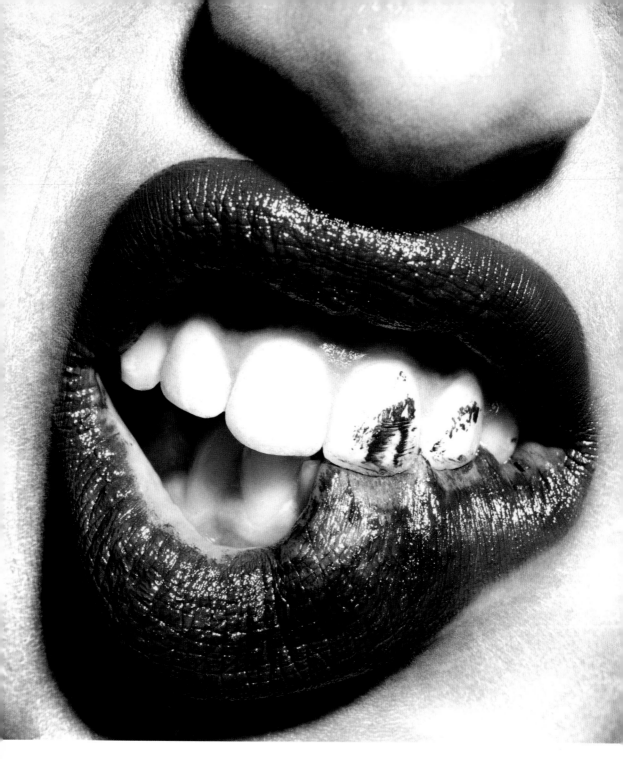

THE
BODY
SAYS
WHAT
WORDS
CANNOT.

martha graham 1894-1991

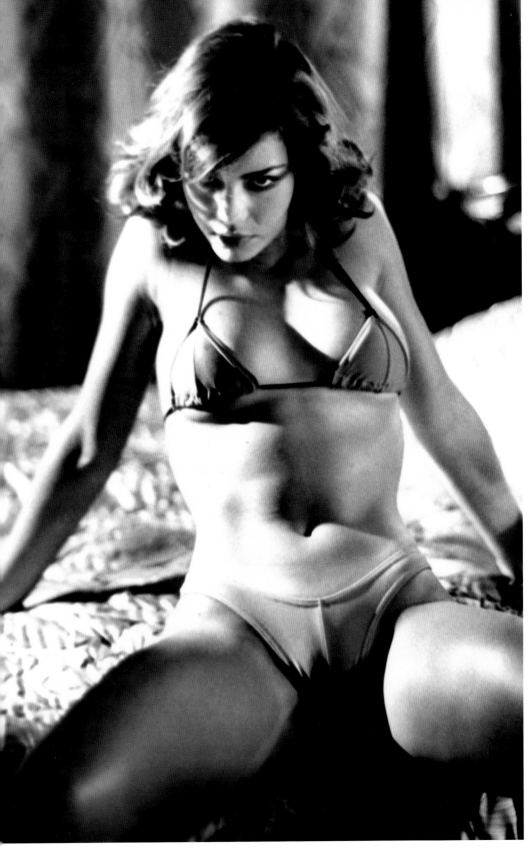

EVERY
WOMAN
DESIRES
TO BE
DESIRED.
BUT
WHEN
SOMEBODY
HAS
GOOD
LOOKS,
THE
PUBLIC
IS
LOOKING
FOR
THE
GREAT

equalizer

...IF
YOU
LOOK
GOOD,
THERE'S
GOT
TO BE
SOMETHING
WRONG
WITH
YOU.

raquel welch

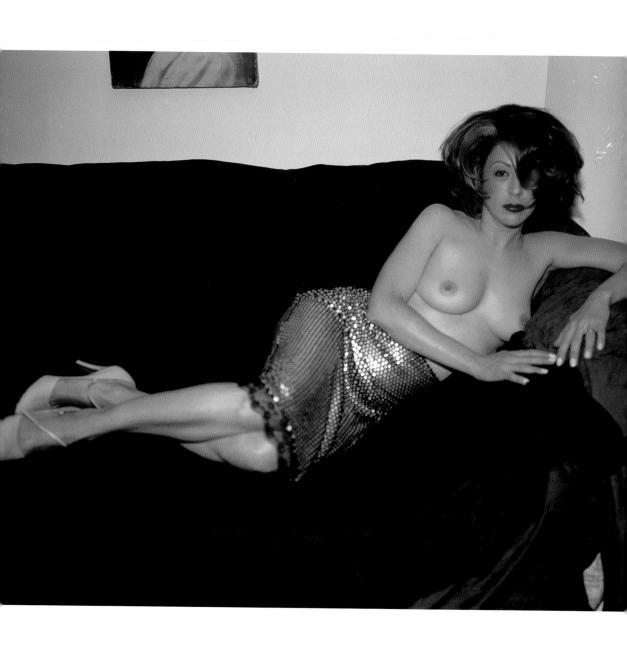

SOME PEOPLE PREFER TO LOOK AS IF THEY experienced hadn't life. MY QUESTION IS WHY? *diane keaton*

if your life is good, beauty is not a freak accident, nor is it rare. nor,
for me, is it perfect. in truth, perfection would kill my idea of beauty.
i like things kinda rough. but sweet, too.
beauty is a rough story sweetly told. *kurt markus*

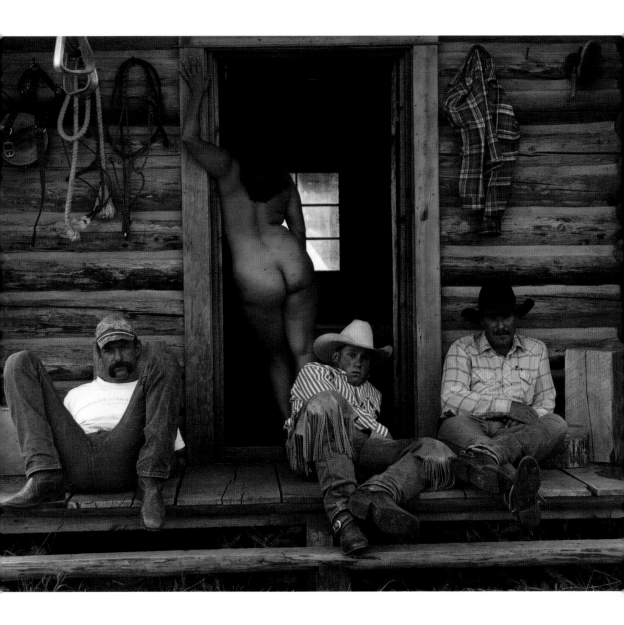

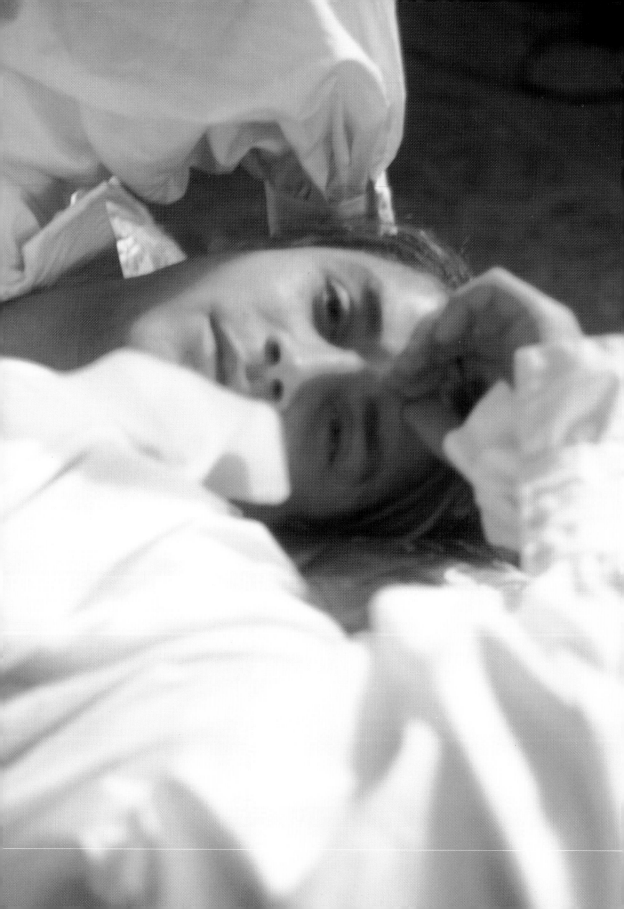

IN THE U.S. YOU HAVE TO BE A deviant OF BOREDOM. *william burroughs*

or

die

BEAUTY
IS
FILTHY
RICH

FRAN LEBOWITZ TALKS...

In this society we have many images of young boys who are disheveled yet beautiful. They might be bike messengers, fishermen, construction workers...they don't have much money, but they don't need it, because their beauty is not dependent on artifice. Where is the equivalent image for women? If you take a beautiful eighteen-year-old girl versus a beautiful eighteen-year-old boy, she will still require help to conform to our images of ideal beauty. Women need money for beauty and largely they get it from men who place a high value on their looks.

I remember once, many years ago, going to a studio to meet a friend. The makeup artist on the shoot was Way Bandy. Way Bandy painted faces on people—he *gave* people their face. This staggeringly beautiful girl with no makeup walks in, and I said, "How can you improve her?" And he went away, spent hours on her, and you know what? When she emerged, she looked fantastic. A billion times better. Which made me realize how accustomed we are to associating beauty with artifice.

I think the pursuit of great beauty by the average person is ridiculous. Not because I'm against artificiality. I'm a fan, and a connoisseur. Nothing interests me more. But it's an absurd pursuit that breeds a tremendous amount of unhappiness. What's striking to me is that, as a culture, we understand that great intellect is a quirk of fate. Yet somehow we still believe we can create great beauty, when, in fact, staggering beauty is as genetic as staggering intellect. Few people would compare themselves to Isaiah Berlin, but every eleven-year-old is comparing

herself to Amber Valletta. Nobody stops to think girls like this are gleaned from a huge pool of beauties, and then gleaned again and again...and then given the best hair, the best makeup...and then airbrushed to death. Nobody looks like Amber Valletta—not even Amber Valletta.

In this society, it's a hindrance for men to be beautiful. Well, it's useful for gay men, yes; but gay men don't have the power. The power in this world is held by heterosexual white men, and always will be. Therefore, the value of every single thing in the world is the value heterosexual white men place on it. These men don't value beauty in men—they deride it, in fact—but they certainly all value it in women. Since we live in a capitalist society, a woman's beauty has value on the open market, which is why beautiful women get the rich guys.

Of course, it's not so valuable for women to be beautiful after forty, because men only associate beauty with youth. You never hear a man saying, as women do, "Doesn't so-and-so look beautiful now that she's let her hair go gray?" That's because, for men, beauty and sexuality are linked, whereas for women they're not.

This is why Cindy Crawford is a male's vision of beauty. Not that she isn't beautiful—she is. But she's the kind of girl who appeals to a high school boy. And the truth is, they're all high school boys. They never change.

I know this book is about redefining beauty. The bad new is, there are no new ideas about beauty. It's wishful thinking.

Depressing? Yes. But people who don't want to be depressed shouldn't call me.

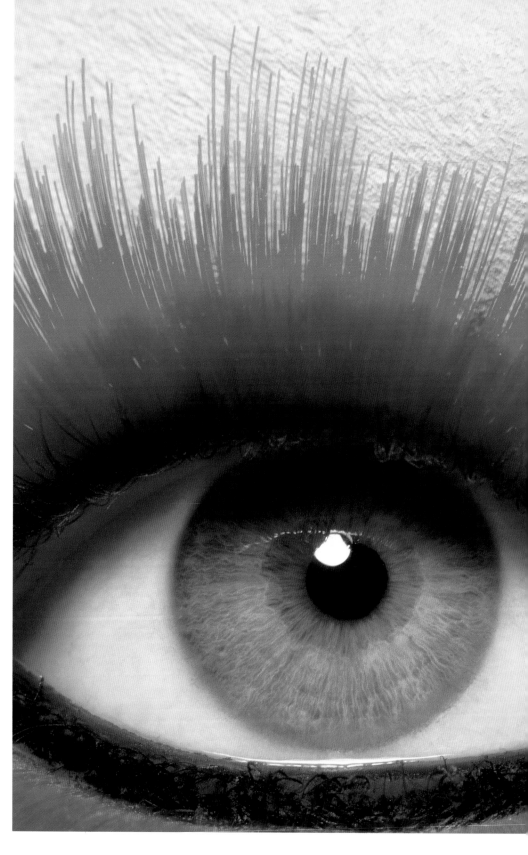

ap
pear
an
ce

is a
powerful
thing.
i know
sometimes
people
can't
remember
a word
you've
said,
but
can
tell
you
exactly
what
you
were
wearing.

ann richards

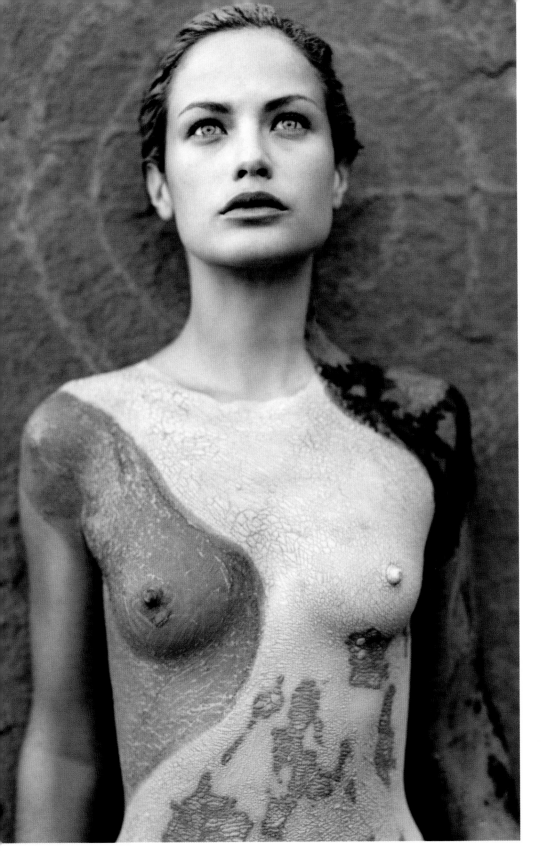

I LOVE TO READ THE

e
Y
e
s

OF PEOPLE. PEOPLE SPEAK WITH THEIR EYES... THEY SMILE WITH THEIR EYES. YOU MAY HAVE A BEAUTIFUL FACE, BUT IF YOUR EYE DOESN'T HAVE A LIFE, YOU'RE DEAD. THE BEST BEAUTY COMES FROM INSIDE, NOT JUST FROM THE FACE. WHEN YOU'RE HAPPY, THE EYES ARE HAPPY. THAT, FOR ME, IS TRUE BEAUTY.

tyen

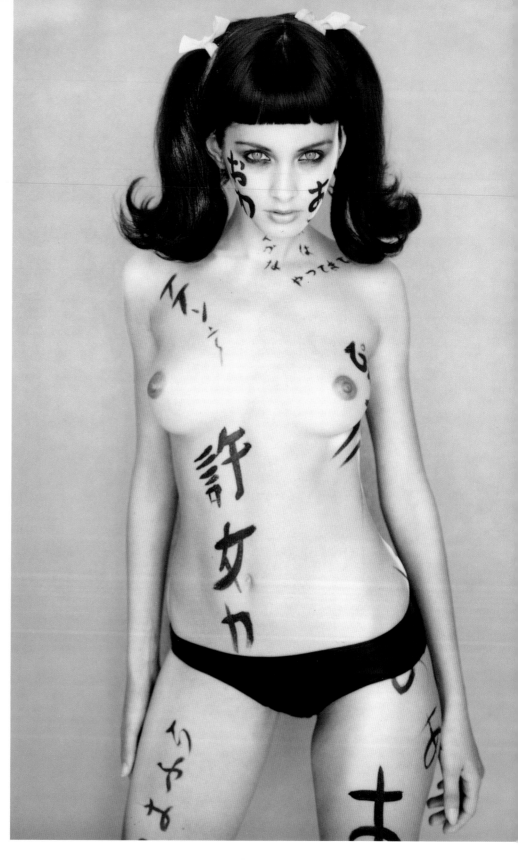

BEAUTY
IS ABOUT
ATTITUDE.
I HAVE
NEVER BEEN
INTERESTED
IN AN OVERLY
MADE-UP
OR FANCY
FACE UNLESS,
OF COURSE,
IT IS FOR A
CHARADE,
OR ON SOME
YOUNG "STREET
BEAUTY." THE
YOUNG DISCO
FACES ALWAYS
GIVE ME NEW
IDEAS. I
WILL NEVER
FORGET THE
KING'S ROAD
IN THE 60s—
IMAGINATION
TAKEN TO THE
EXTREME. OR
THE MIME
MARCEL
MARCEAU.
HIS WAS A
PUT-ON
FACE, AN
APPLIED FACE,
SO PLAINTIVE.
A COSMETIC
BEAUTY
DOESN'T
INTEREST ME
IF IT'S
BLAND IN
EXPRESSION.
THERE MUST
BE SOMETHING
HAPPENING
ON THE FACE.

polly allen mellen

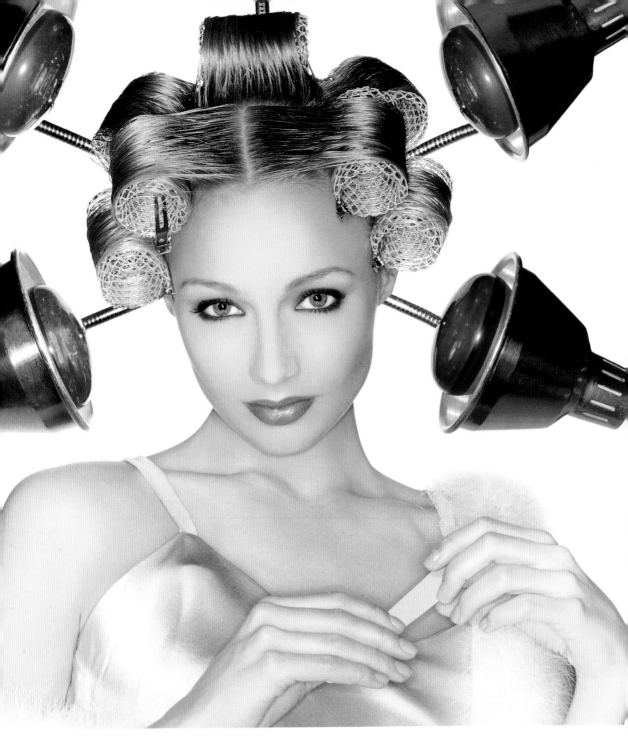

I THINK VANITY IS A GOOD THING. IT MAKES US ALL get out of bed in the morning.

sherell aston m.d., plastic surgeon

i remember
overhearing a
conversation
between my
mother
and
father
when
i was
about
twelve...
to the
effect
that
anjelica

WASN'T
GOING
TO BE
A BEAUTY.

my
way
of
dealing
with
that,
even
then,
was:
i'm
going
to make
myself
beautiful.
i might
not have
physical
perfection,
but

I'M GOING
TO THINK
MYSELF INTO
BEING
BEAUTIFUL.

anjelica huston

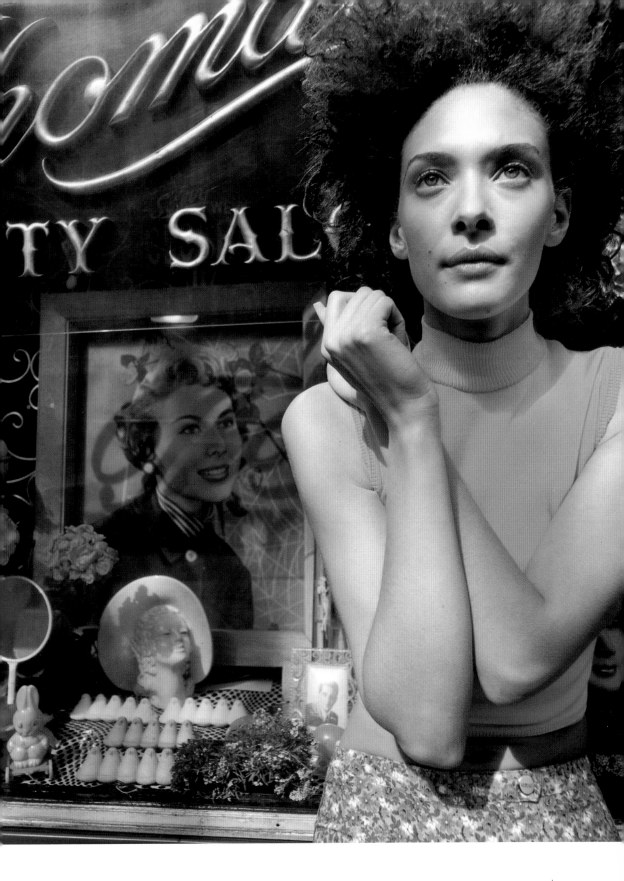

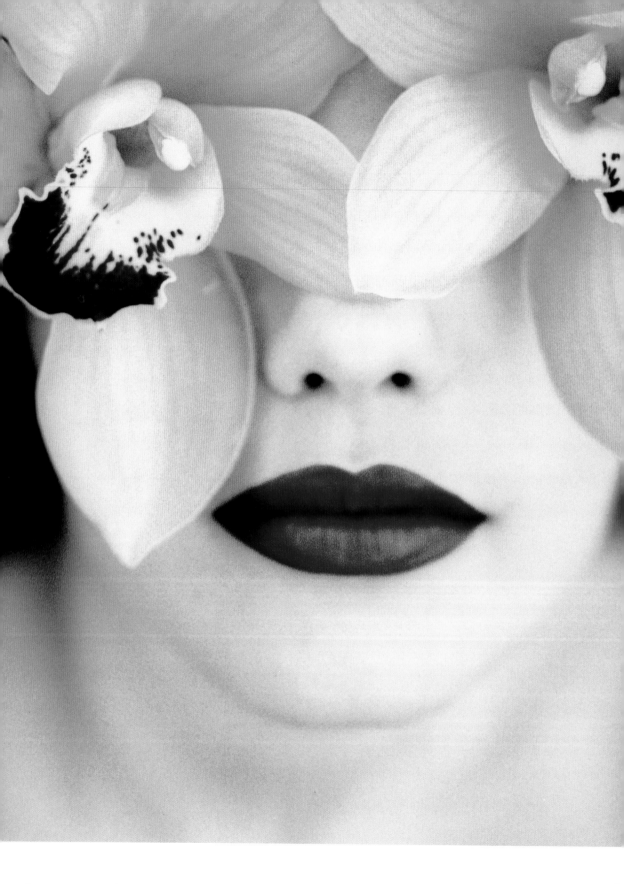

IT IS SAID THAT "BEAUTY COMES FROM WITHIN" and "beauty is being yourself." Noble sentiments indeed, but I'm convinced that what's good for the shell is also good for the soul.

We've certainly got technology on our side—laser tooth whitening; non-fading hair dye; alpha hydroxy acids; lipstick that lasts all day! And enthusiastic beauty experts in spades— the waxers, the pluckers, the facialists, the cutters and colorists, the trainers, the manicurists and toenail trimmers, the makeup artists, the perfumers—all conspiring to render womankind more ravishing than a lifetime of good deeds ever could.

Products, treatments, miracle-workers: This is the stuff of beauty. And beauty is the stuff of life.

Recently, even as she lay terribly ill with cancer, my very dear aunt placed an urgent call to me in New York: "I've just smelled something WONDERFUL on your mother! She says it's Allure and I MUST have some!"

The package was rushed off; we didn't speak again until I went to visit her on her deathbed a few short weeks later.

Sifting through her makeup bag one afternoon, looking for something to amuse both of us, I found the flask of perfume and misted her. Her eyes were closed; she was exhausted and near the end.

"Wonderful! Wonderful!" she enthused. "I feel so pretty."

Exactly.

amy astley

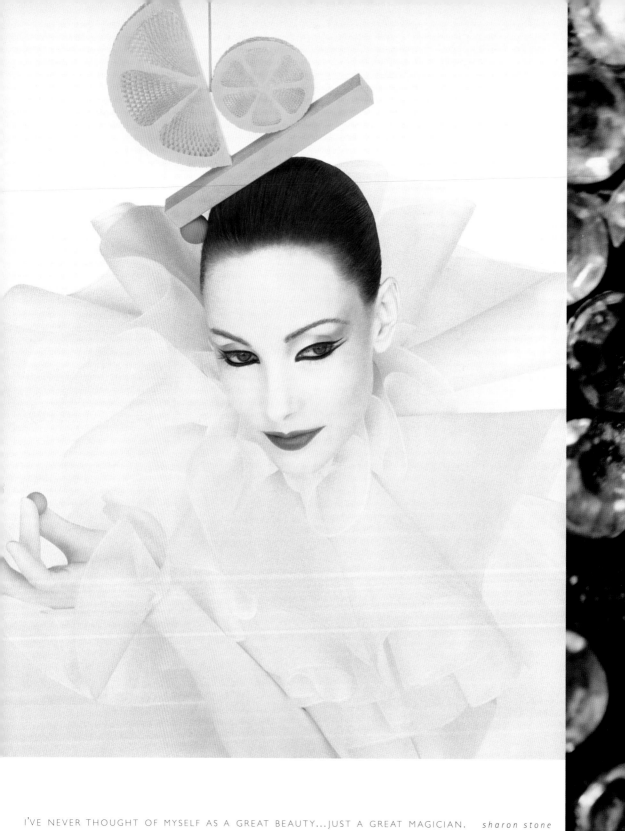

I'VE NEVER THOUGHT OF MYSELF AS A GREAT BEAUTY...JUST A GREAT MAGICIAN. *sharon stone*

our
culture
is
so
obsessed
with
body
perfection
and
beauty...
the
message
is
that
if
your
chin
were
pointier
or
your
chest
bigger,
you'd
be
happy.
all
of
this
presumes
that
success
is
found

under
the
gaze
of
others.

jodie foster

steven klein / *mathu anderson "the jeweled eye"*

A THING OF BEAUTY...

BY AMY GROSS

It's the end of summer as I write this, and I'm out in East Hampton, a Long Island resort that gets a lot of bad press for being trendy. It's true that herds of Jaguars, Mercedes, and Range Rovers dominate the parking lots, the restaurants are jammed with people whose names appear in bold face, and crossing Montauk Highway is a good way to induce a heart attack. But the village was voted one of the five prettiest in the country, and all summer I've been interested in the fact that I stare at the gardens and houses with the same passion now as I did twenty-five years ago, when I first saw them. There's a house on Main Street, rimmed in gingerbread, that I seem to need to study each time I pass. This is beauty, or one form of it, and it has something to do with being inexhaustible. I can't get enough of these hedges and houses, these tree-shadowed lanes, the sublime simplicity of weathered cedar shingles, expansive white porches.

I have the average New Yorker's contempt for the same-old, same-old, yet I'm always awed at the constable-like arrangement of pond and trees and meadow just west of a majestic (but famously restricted) country club. I'm living in a house on Three Mile Harbor and I wake up to the sight of sailboats and their masts reflected in water, sometimes in mist, other times blindingly sunstruck. The image stuns me, day after day. The wild-armed junipers and walls of arbor vitae, the grandeur of copper beeches near the pond, the ghostly santolinas and lavenders, and let's not even start with the wisteria...I eat these all with my eyes. Or try

to. I want to devour these images, memorize them, own them, and I can't. The beautiful thing is ungraspable, unmasterable, unendingly tantalizing. In front of a great painting in a foreign city—say one of Cézanne's *Bathers* in Paris—I think: I have to remember the colors because reproductions never get it right and nothing but the original has the force that is pinning me to this spot. The same frustration —an exquisite frustration—can make watching dance painful: It will never be this way again and that's tragic. The two—exquisite and tragic—get very close in beauty. It's all passing and it's perfect. It floods the screen of your mind, it overflows your heart.

Beauty in a person is more complicated. If you were to walk through a garden and suddenly come upon a fat, fresh peony, it would startle its way into your attention, it would insist —but you could stare back freely and move on. Beauty in a person is just as startling, but staring dumbly is usually not allowed. Beauty in a person is confusing. The visual receptors in the brain are thrumming, blocking the other senses and generally interfering with normal mental functioning. It's hard to hear, difficult to form sentences. We know from world history and rock & roll that physical perfection can induce madness, swoons, suicide, wars.

But there's another kind of human beauty that doesn't derive from physical equipment. In fact, I don't know its source, but it comes through a person's smile or eyes as radiant energy, aliveness, attention. It jumps the gap between the two of you. It melts all those crispy interior walls. *You* end up feeling beautiful. Again, there's no getting enough of it.

Now if we could just do something about the ugliness at that country club....

for the
ancient
greeks,
beauty
was
THE
GIFT
OF
THE
GODS.
they
knew it
should be
admired,
because
they
knew how
ephemeral
it can be.

carolina herrera

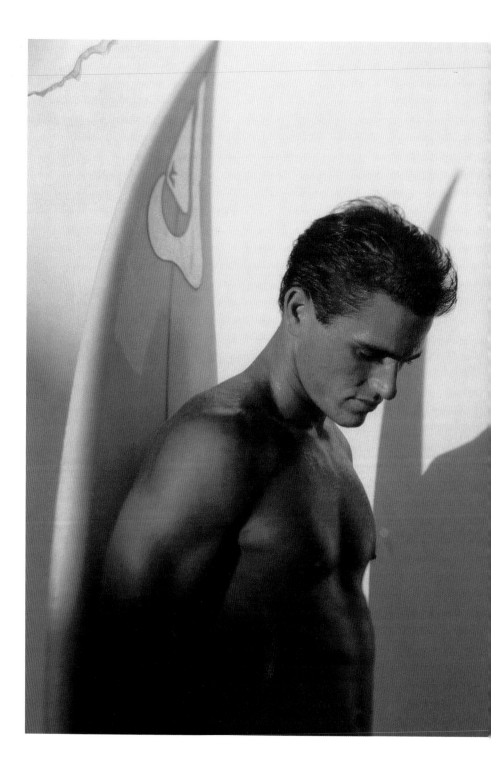

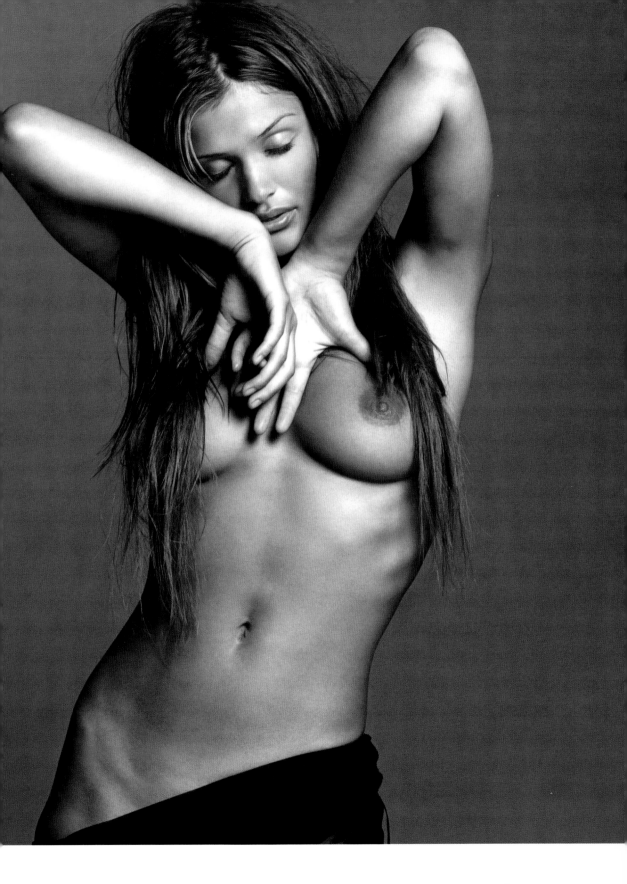

THERE
IS A
DIFFERENCE
BETWEEN
PRETTY
AND
BEAUTIFUL.
BEAUTY CAN
ASTONISH US.
INSPIRE US.
MAKE US
DANCE.
MAKE US
WEEP.
BEAUTY
CAN BE
MAGICAL.
BEAUTY CAN
TRANSFORM US.
BEAUTY
LETS OUR
SOUL SING.
BEAUTY CAN
HAVE SUCH
DEPTH THAT
YOU DON'T
EVEN NOTICE
IT AT FIRST,
OR EVER.

macduff everton

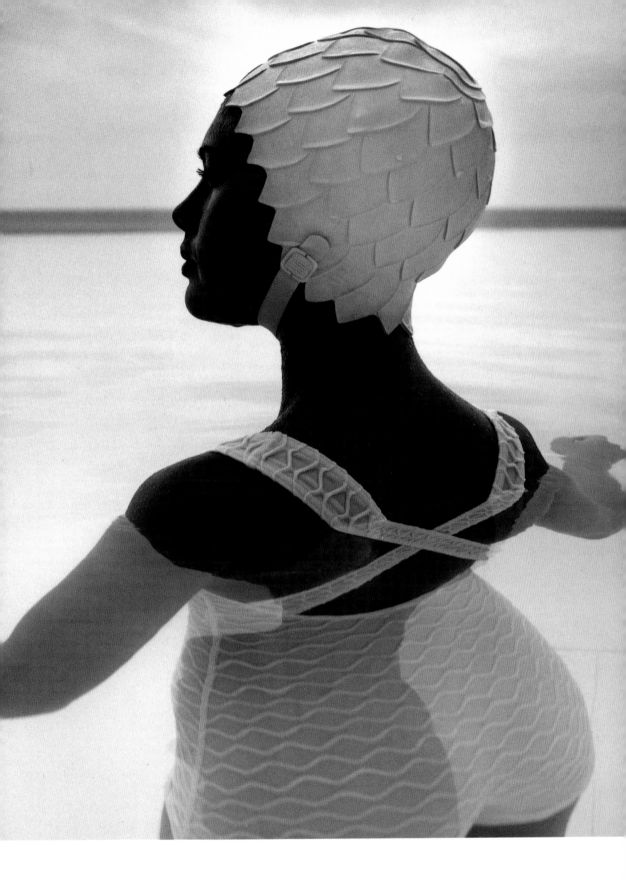

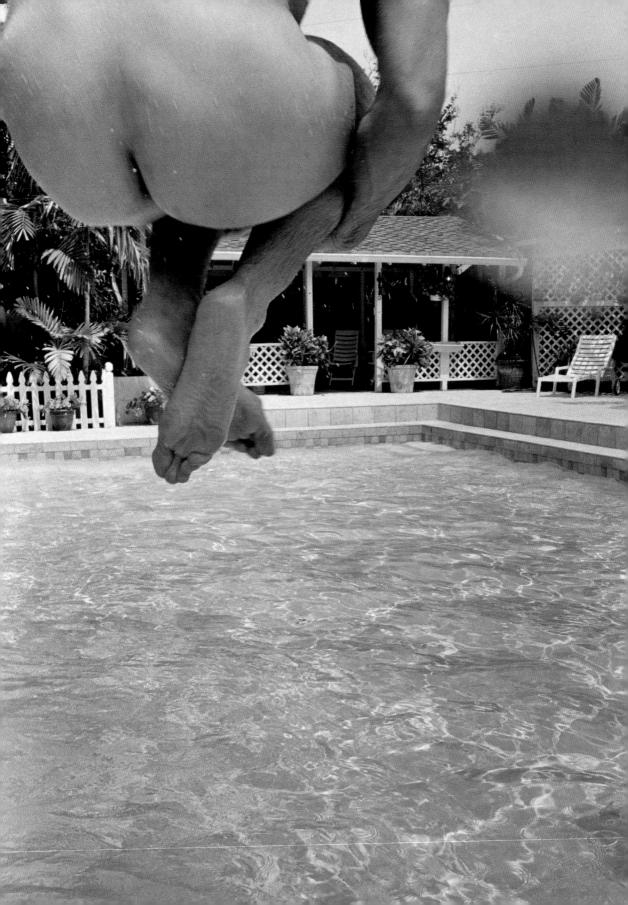

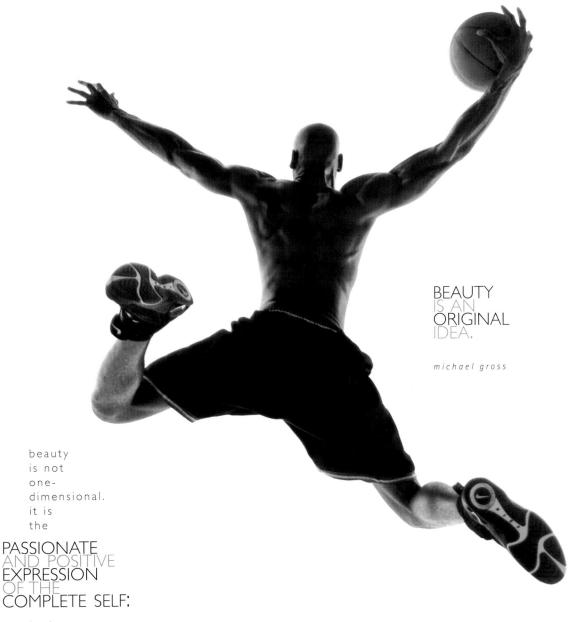

BEAUTY
IS AN
ORIGINAL
IDEA.

michael gross

beauty
is not
one-
dimensional.
it is
the

PASSIONATE
AND POSITIVE
EXPRESSION
OF THE
COMPLETE SELF:

body,
mind,
and
actions.

vidal sassoon

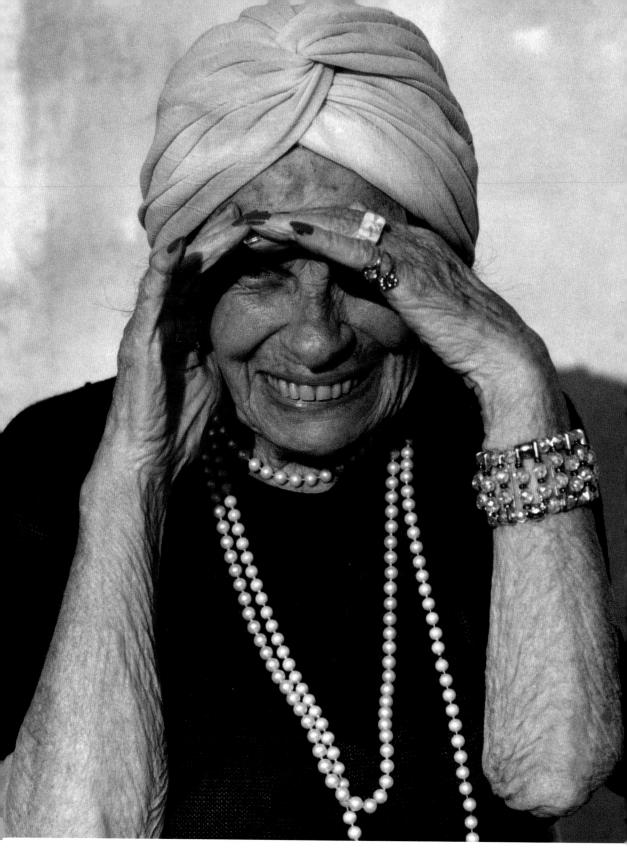

IN AMERICA, YOU LOOK AT A WOMAN
WITH CROW'S FEET AND SAGGING SKIN
AND PEOPLE SAY, "SHE SHOULD HAVE
SOMETHING DONE." PEOPLE IN EUROPE
DON'T FEEL THAT WAY. THEY BELIEVE AGING
SHOWS PERSONALITY. SOME WOMEN IN
AMERICA DON'T LOOK REAL ANYMORE.

laura mercier

beyond
the
surface,
beauty
is
what
a
woman
outwardly
offers
through
the
grace
of
her
gestures,
the
confidence
in
her
walk,
the
strength
of
her
stare.

mark eisen

I FIND

per
im
fec
tion

THE MOST
INTERESTING
THING ABOUT
A PERSON.
MY SENSES
ARE
USUALLY
DRAWN
TO THE
GESTURES,
THE
DETAILS
OF A
PERSON'S
FACE OR
CARRIAGE,
THAT
ILLUMINATE
HOW
THEY
HAVE
LIVED:
TINY,
ELEGANT
LINES
OF A
STORY,
THE WAY A
BELLY LAUGH
SIGNALS
GREAT
PASSION.

jodie foster

betty friedan

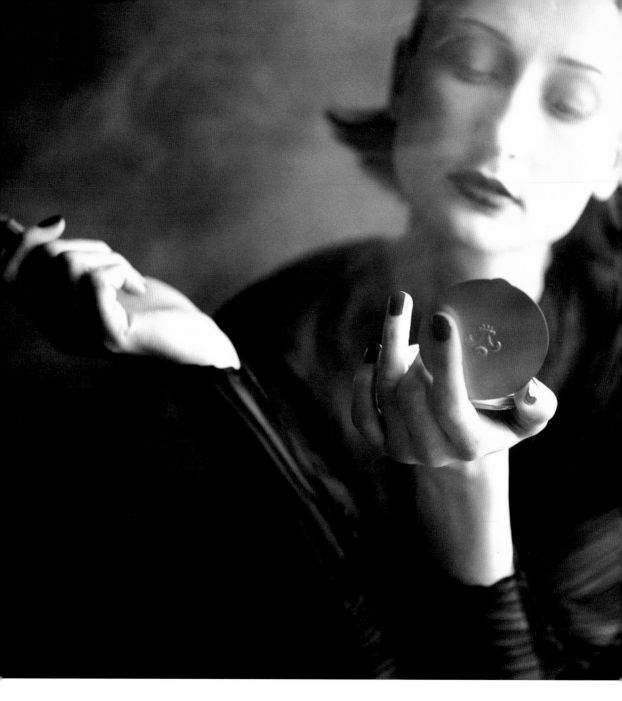

BEAUTY SHOULD BE PORTIONED TO ACHIEVE ITS TRUE EFFECT...

beauty for me means harmony.
harmony between your inner and outer self.
between your soul and your aura.
between your spirit and your charm.
beauty depends on your character's richness.

jil sander

A SINGLE FLOWER,
A SMILE,
A LINE OF A BOOK,
AN ARIA FROM AN OPERA,
A PUPPY'S EAR.

bill blass

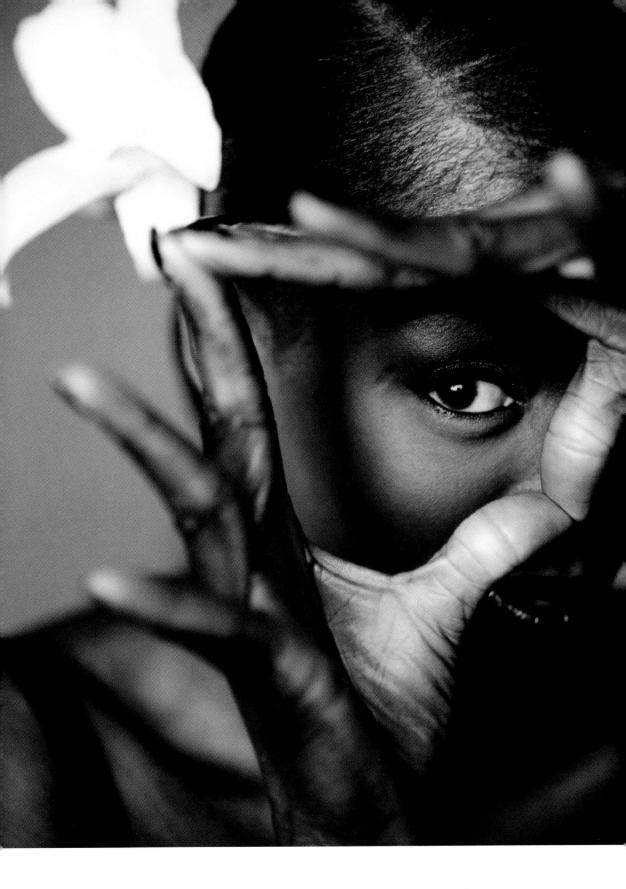

YET
A
BEAUTIFUL
FACE
IS
BEAUTIFUL
THE
WORLD
OVER.

EVERY CULTURE HAS CERTAIN NUANCES OF DIFFERENCE IN WHAT IT CONSIDERS BEAUTIFUL,

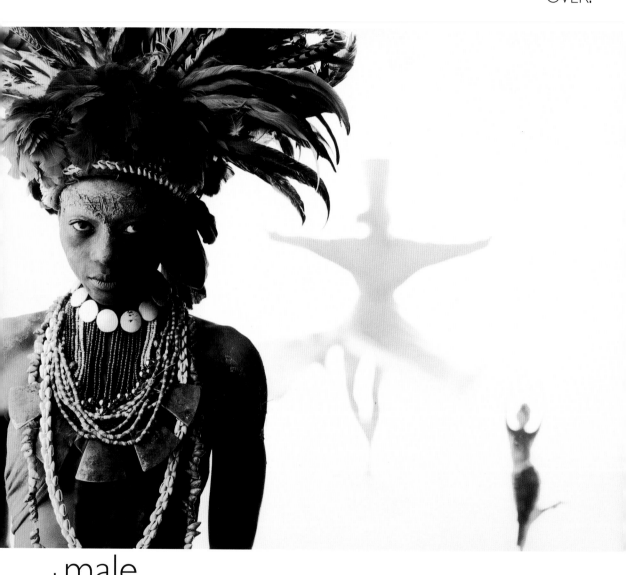

male
beau
ty will be important in the next century: men will wear jewelry, makeup,
feathers, pearls—all that was considered mostly for women in the twentieth
century. narcissism will play a big part. so, too, will a mixture of different races.

karl lagerfeld

HE HUMAN BRAIN HAS A NATURAL APPRECIATION FOR SYMMETRY, PROPORTION, BALANCE, TONE, SHADE, SHAPE.

helen fisher

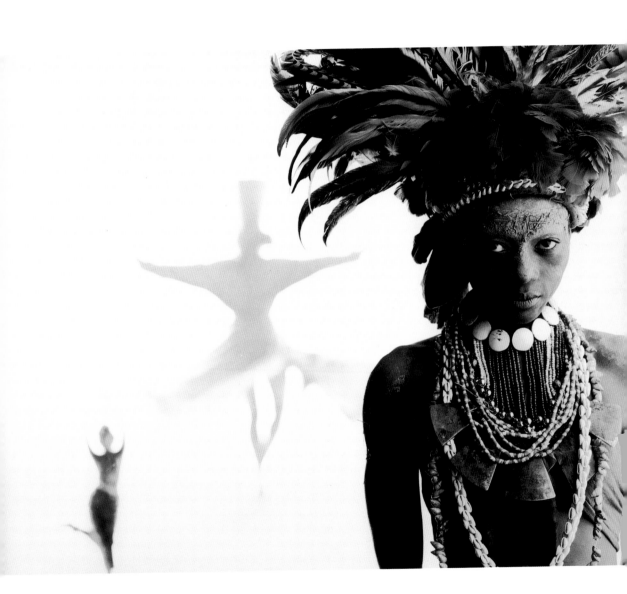

do we want to take this one quality (beau
and assign the primary worth of a person on that basis? if you ty)
reduce people to one aspect of their identities, you get a very distorted
and ill-functioning society.

naomi wolf

DREAM
GIRLS

BY MICHAEL GROSS

We reach an age where we no longer want to give in to fantasies about the perfect woman. But we have those fantasies anyway.

We have them whether we are young or old, man or woman, or something in-between. A woman thinks about the woman she would like to be. A man dwells on the woman he would like by his side. Some men even dream of the woman they'd like to be.

Although it's unlikely that there is one perfect woman for all of us, we all feel the need to celebrate the perfect woman. We strive for perfection, even though we know it is difficult, if not impossible, to achieve, and we celebrate ideals, even if they only exist in our minds.

Who is the perfect woman for the 1990s? In considering that question, it is necessary to reject Cindy Crawford and Claudia Schiffer, even though they have embodied femininity for the last decade. The perfect woman for this decade would never allow herself to be as overexposed as supermodels are.

With all due respect to the Princess of Wales (another paradigmatic possibility), mystery is a necessity, and our familiarity with overexposed tabloid princesses and catwalk queens breeds ennui, if not outright contempt.

It may help to take a moment to dwell on diversity, because it is the hurdle any discussion of female perfection must jump nowadays. We are increasingly aware that the ranks of perfection are riven with infinite variation. There are shapely women and comely women, tall women and short women, stylish women and bookish women, demure women and depraved women, blonde, brown, and black women, gay, straight, and bi-women, each and every one of them with particular charms.

Researching my book on fashion models, I met dozens of beautiful women. Men expressed their envy. That's because those who don't know fashion models are encouraged, by the models and the people who employ them, to think that in private models are ideal women. After all, models stand in for millions of women in advertisements and magazine photographs, which use idealization to tickle aspiration and set off waves of consumption. But few of the models I met—their beauty, enchantment, and allure notwithstanding— were perfect. In my mind, imperfections are what make the most beautiful women interesting. Men and women share, to a remarkable degree, the same standards of female beauty. There are differences in taste. Women seem to prefer to look at women who look good in clothes, while men prefer

women who look good without them. Nonetheless, in my experience, we agree as often as not. Cindy and Claudia appeal to all in equal measure. Even features, taut physiques, clear skin, bright eyes, and shiny hair also go a long way with almost all of us.

Lately, both sexes have reached an agreement about the very young, very thin women who've been cropping up more and more in advertisements and fashion magazines. We don't like them very much, and we believe that they create a bad—as opposed to perfect or ideal—image for women, some of whom apparently consider the constant bombardment of images of gaunt girls encouragement to take on unhealthy habits like not eating, or worse.

The ideal woman bears absolutely no resemblance to Kate Moss. I will grant Kate her coupled contentions that she eats steaks and potatoes all the time, and can't put on a pound as hard as she tries. But today's ideal woman needs to be just a bit more realistic than that. Typically, only teenagers have teenage metabolisms, and only models can survive on the fashion diet of cigarettes, champagne, and constant indiscriminate praise. So if it's not Cindy or Diana or Kate, who is today's ideal woman? In polls, first ladies, royals, athletes, and television hostesses are the most-admired women of our times. But many of them make these

lists by simple virtue of visibility. Rosalynn Carter, Barbara Bush, and Queen Elizabeth may be admirable, but none strikes me as a woman you'd want to be or one you'd want to be with. And besides, the first two got their positions via marriage and the third through birth.

Hillary Rodham Clinton, similarly cited as admirable, has more going for her than the right spouse or lucky genes. She is smart as a whip, but her public face (or rather, faces, as she seems to switch hers daily) is hardly welcoming. We admire her, sure, but does she lead a happy, healthy, fully-rounded life?

Newly cynical after several decades spent watching false gods fall on television, we now suspect that almost all public people have feet of clay. Once, we viewed them as larger-than-life, paragons of vision, strength, courage, commitment, wholesome accomplishment, and social concern. Today, we wonder what they're really like behind their all-too-perfect public images. Too often, they have proved to be tarnished or dysfunctional. Why else would they choose to live in the public eye instead of the real world?

Maybe there really are no more heroines and heroes. But we still need role models. So perhaps we should pick bits and pieces and blend them into the ultimate woman.

If we combined Madonna's drive with Roseanne's wit, Steffi Graf's prowess, Mother Teresa's goodness, Julia Roberts's smile, Eleanor Roosevelt's heart, Camille Paglia's irreverence, Jil Sander's style, Jeanne Kirkpatrick's intelligence, Maya Angelou's expressiveness, Katarina Witt's grace, Christy Turlington's face, and Helena Christensen's body, would we end up with someone we'd worship—or someone fearsome? But Frankenstein's monster isn't the answer either. Just as you'd want the perfect woman to stick around, you'd have to want to be around her, too.

Speaking of Frankenstein's monster, plastic surgery is a major negative when it comes to the perfect woman. When I covered fashion shows, we'd joke each season about which models had been "done" since we'd seen them last. They looked great in photographs, or paused at the end of the runway, but not when they were in motion. And perfect women don't pose on a pedestal anymore; they move, they do.

The fact is, the perfect woman is not a collection of spare parts, but an integrated whole. She is not an image, but a reality. Not a photograph or light and shadow projected on a screen, but flesh and blood. Not just flesh and blood, but also mind. Not just mind, but also spirit. Once, the perfect woman was a fantasy. Now, she must be real. Which means she will be imperfect. So what then of perfection, and that elusive, mysterious woman who we would call its contemporary embodiment? I know her, but then again, I don't. I wish I could see the perfect woman, but these are the 90s and so I know in my bones that appearances deceive, and the chances are good I'd be wrong. I can't define her, because when I do, another woman walks by, trailing the scent of a perfume made with common oils mixed in unique proportions, getting me all confused.

Perfect femininity can only be found at the core of this contradiction. Today's perfect woman knows SHE'S NOT PERFECT, BUT SHE TRIES ANYWAY.

i've always been
inspired by movie
stars from the 30s
and 40s. i still am.
but today the
problem with our
whole culture—
our stars, our
magazines, our
fashion: it is no
longer aspirational;
it used to give women
something to look
up to. now, instead
of looking up,
everyone's looking
down; what's fashionable
is what's "real."

jackie rogers

my earliest ideas

of beauty
came from
that amazingly
vivid threesome
called the
supremes. not
only did
diana and
her two
girlfriends put
a bouncy
smile on
top of
teen angst,
which made
it easier
for me
to get
through those
blunder years,
but their
clothes matched
their effervescence
with every
swatch of satin.
their look
was pure
glamour.
i wanted
to be them,
and am still
trying, despite
the intrinsic
problem of
being white
and male.

michael musto

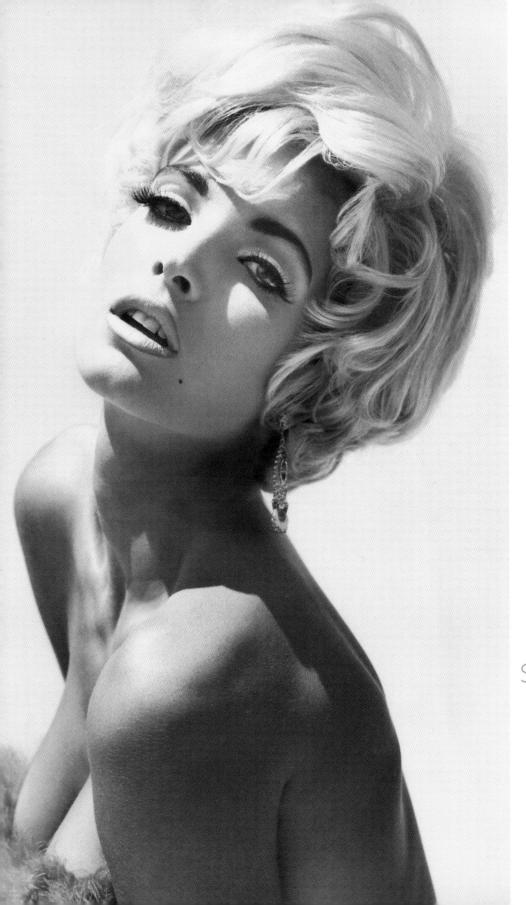

i
think
we
all
still
want
glamour
but
in a
realistic
way. i
don't
think
marilyn
monroe
could
have
made it
today,
because
we'd
laugh
at
her

ob
ses
sion

with
being
glamorous
and
sexy.

elsa klensch

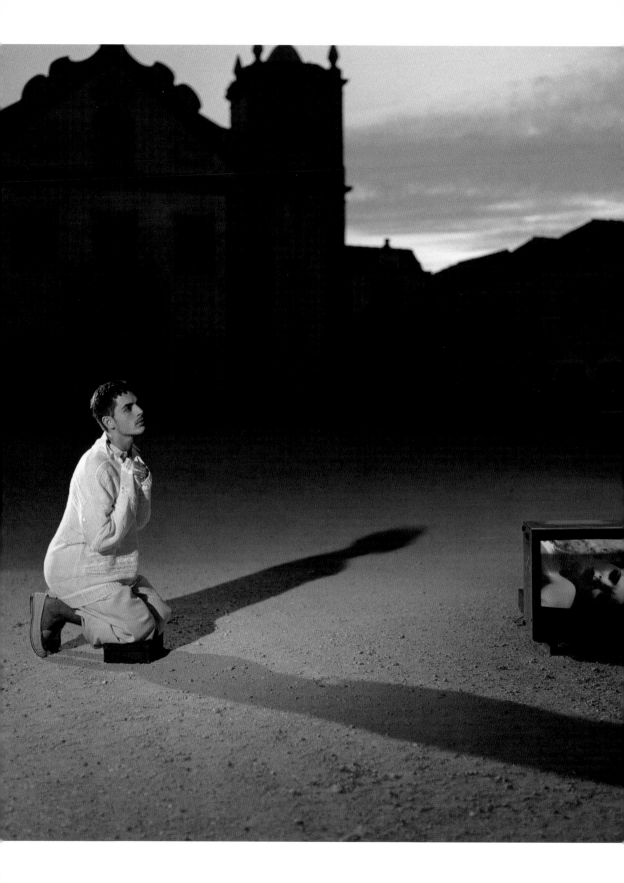

until the age of capitalism, every civilized country enacted laws attempting to control sumptuous dress. For years the church has railed against the deceit and vanity of fashion, and medical doctors have expressed horror at the risks and dangers people incur in the name of beauty. none of it has made a dent.

nancy etcoff

SUPREME MOMENTS IN THE HISTORY OF CIVILIZATION, AS IN ANCIENT EGYPT, CLASSICAL ATHENS, OR RENAISSANCE FLORENCE, WERE ALWAYS ACCOMPANIED BY THE WORSHIP OF BEAUTY. FEMINISM IS SHOT THROUGH WITH PURITANICAL JUDEO-CHRISTIAN ASSUMPTIONS, WHICH EXALT THE SOUL OVER THE BODY AND MORALISTICALLY DEVALUE THE PHYSICAL REALM. TODAY THE HUMAN HUNGER FOR BEAUTY IS SATISFIED BY THE MUCH-MALIGNED FASHION MAGAZINES, WHICH ARE GLORIOUS ART FOR THE MASSES.

camille paglia

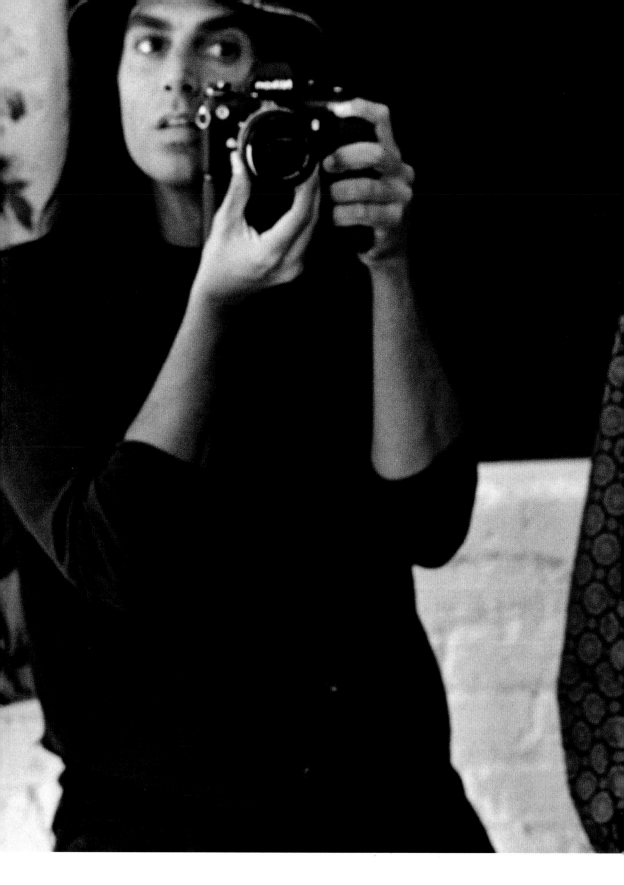

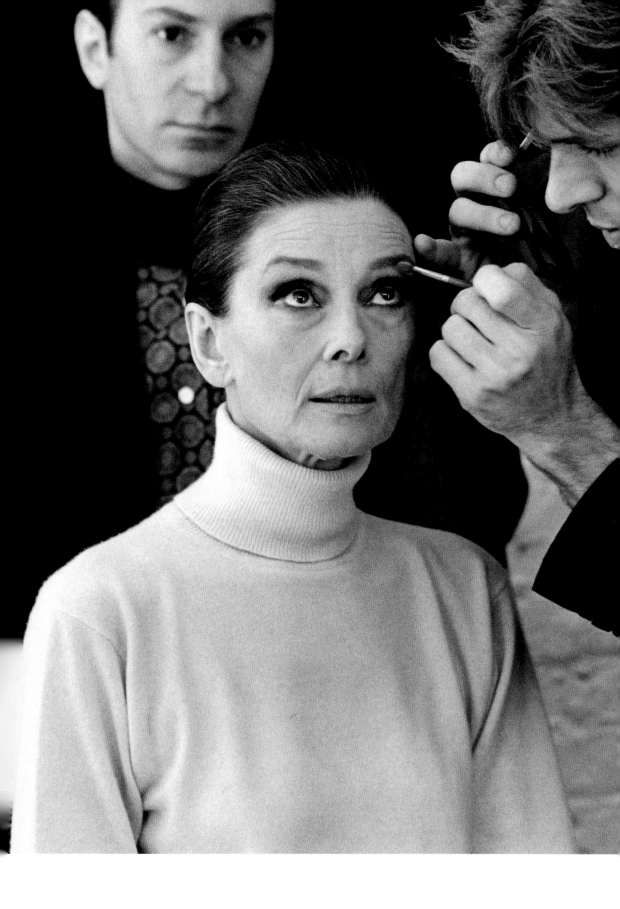

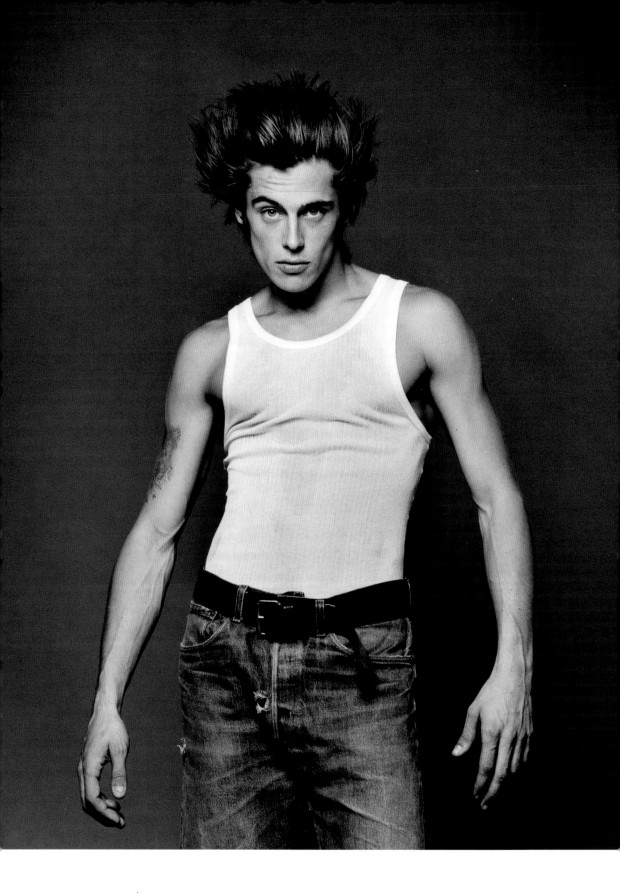

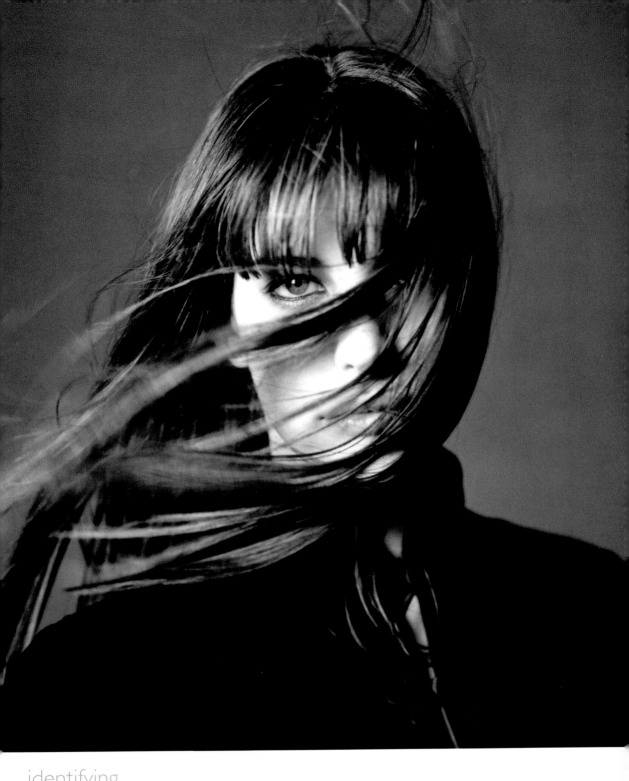

identifying
is a
delusion. I THINK IT CAN ONLY BE ENORMOUSLY FRUSTRATING TO THOSE WHO FALL FOR IT
BECAUSE THEY CAN NEVER LIVE UP TO THE IMAGE. AND THERE IS REALLY NO
FUNDAMENTAL NEED TO RESEMBLE AN IMAGE ONE LIKES.

serge lutens

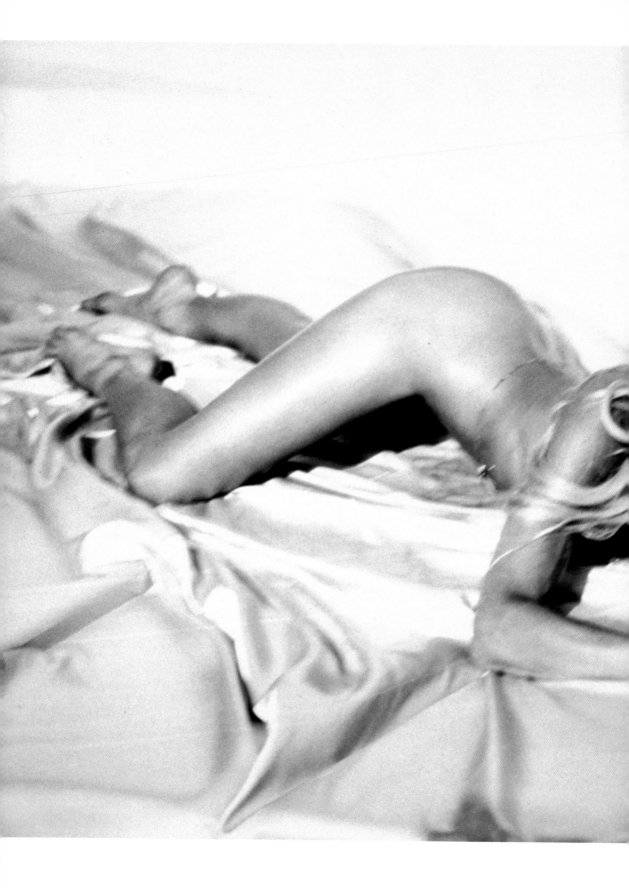

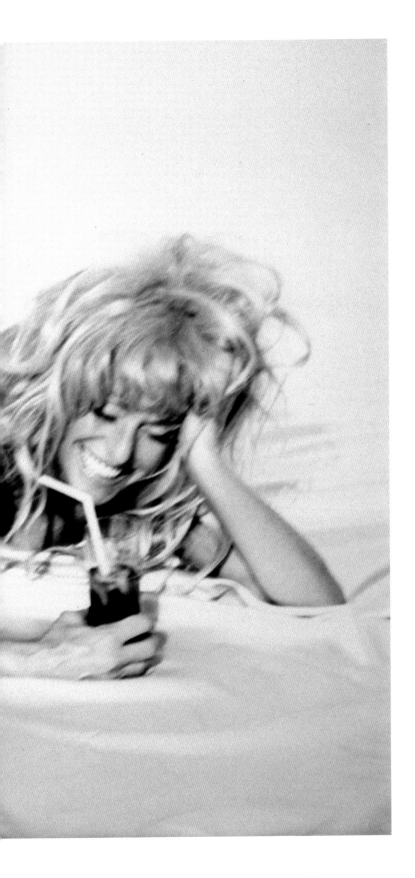

here's my
idea of
america: TALL,
BIG,
BLONDE,
AND
BOUNCY.
if i close my eyes
and think french
it's: SMALL,
DARK,
CHAIN-
SMOKING,
CHANEL
SUITS.

the english are not
quite as healthy as
americans, not quite
as small and dark
as the french.

elizabeth hurley

i sent two
models on
a trip together
to do bathing
suits. one girl
called me
and said,
"oh, my god, i
wish i was her;
she's got such
a lean body
with perfect
muscle tone."
and the other
one called me
up and said,
"i was so
ashamed
of my
figure,
because
SHE'S
SO
WOMANLY."

monique pillard

MY
IDEAL
OF
BEAUTY
AND

glam our

AND
SEXINESS
IS
EDIE
SEDGWICK.
THE
SHORT
SILVER
HAIR,
THAT
FACE,
THE
BLACK
TIGHTS,
THOSE
CHILD-LIKE
LIMBS...
BUT,
MOST
OF
ALL,
THE
WAY
SHE
INVENTED
PERSONAS
FOR
HERSELF.

amy astley

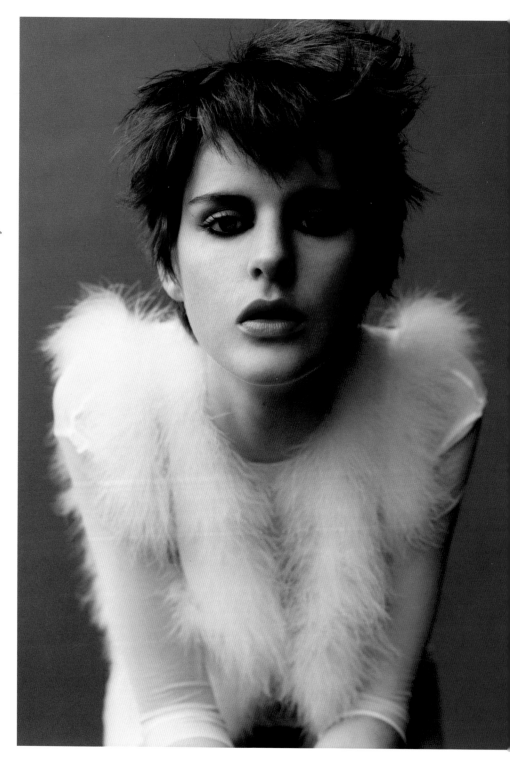

THERE'S
A
MESSAGE underneath every picture of every model. the picture says "look at me, i don't mind. i'm available to you. i'm yours." which is not the way things really are. back here on planet earth, women don't like being stared at. *eric bogosian*

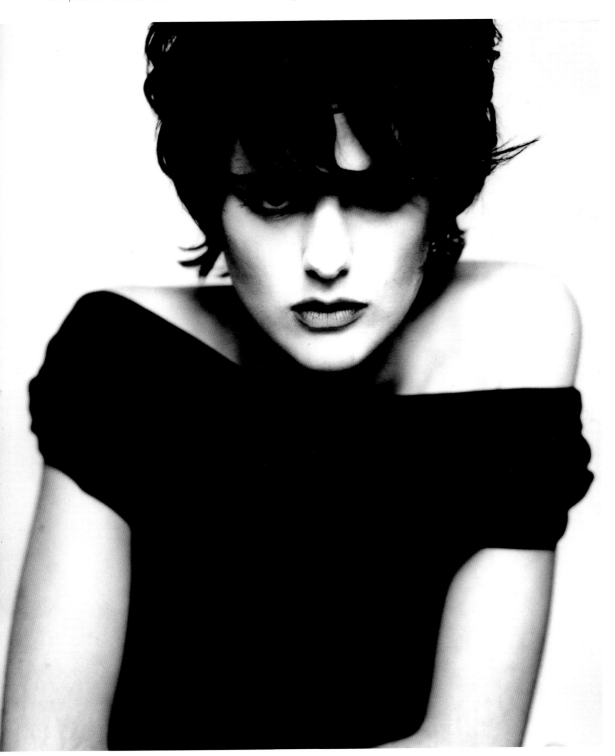

Liz Tilberis, Harper's Bazaar's editor-in-chief sat down with three of her editors—Annemarie Iverson, Eve MacSweeney, and Gale Hansen—to talk about beauty. Their visual definition: this "un-modely" picture of a modern beauty, Amber Valletta, taken by Bazaar photographer Patrick Demarchelier.

LT: So, what is beauty?

AI: Beauty, for me, is inconsistent, asymmetric, imperfect. Beauty cannot ever be perfect or it risks appearing unreal.

LT: Real beauty is about many things: style, elegance, the way a woman lives her life. It has nothing to do with just her face or just her hair. It has nothing to do with mascara or lipstick. It's about the complete person.

GH: Sometimes I wish I could just throw away all my makeup and free myself from it.

LT: When I was a young girl, I was terribly upset because my hair wouldn't curl. I used to put rollers in every night and have an excruciating night's sleep. Suddenly I realized it really didn't matter if my hair didn't curl. Women have to come to terms with who they are.

AI: It's actually a good moment to be talking about beauty because it's a time of change. Different types of beauty are being celebrated. It's now about the individual. Models like Guinevere, Carolyn Murphy and Stella Tennant—the models we are now using—would they have been successful ten or twenty years ago?

LT: When I first started doing sittings in the mid-70s, I had a hairdresser on the shoot, never a makeup artist. Then as we got more and more daring, we didn't have hair or makeup. It was a moment when the model herself was more important than the way she looked. I'd get upset when a beautiful girl would come into the studio and the makeup artist would apply so much makeup to her face that the model would actually look worse on the set than when she first walked into the studio. Today, makeup artists and the makeup are so much better, and makeup pros put on much less makeup. The beauty of the model, rather than her makeup, comes through. During the 70s and early 80s, beauty was fake: the model wore a blank face. Today, that's old fashioned. We're lucky. Although we use lots of products and spend money on them, we live in a very unmadeup-looking age.

EM: The most interesting aspect is this idea that definitions of beauty have loosened up.

AI: It's liberating. And we try to express that in every picture we take. Hopefully, young girls growing up today and trying to get through that horribly painful time of adolescence, see models who look like them, so that they do not feel like they have the "wrong" face.

GH: As the mother of a daughter, I worry she'll be judged by her looks. I see it happening already. She's rewarded for being cute.

LT: With boys, you don't have that worry. It's lovely if they grow up to be handsome, but there's no pressure to be beautiful.

EM: If we can instill confidence in our daughters, they'll feel beautiful, rather than constantly worry about other people's judgments of them.

LT: That's true. And for women who are not raving beauties, there are a lot of things they can do to make themselves feel better.

GH: You know, I enjoy using makeup—even though I know it's not going to change my looks. Makeup is a source of pleasure.

LT: Yes. Having my makeup done, for me, is better than a massage.

AI: Better than sex?

LT: I didn't say *that*.

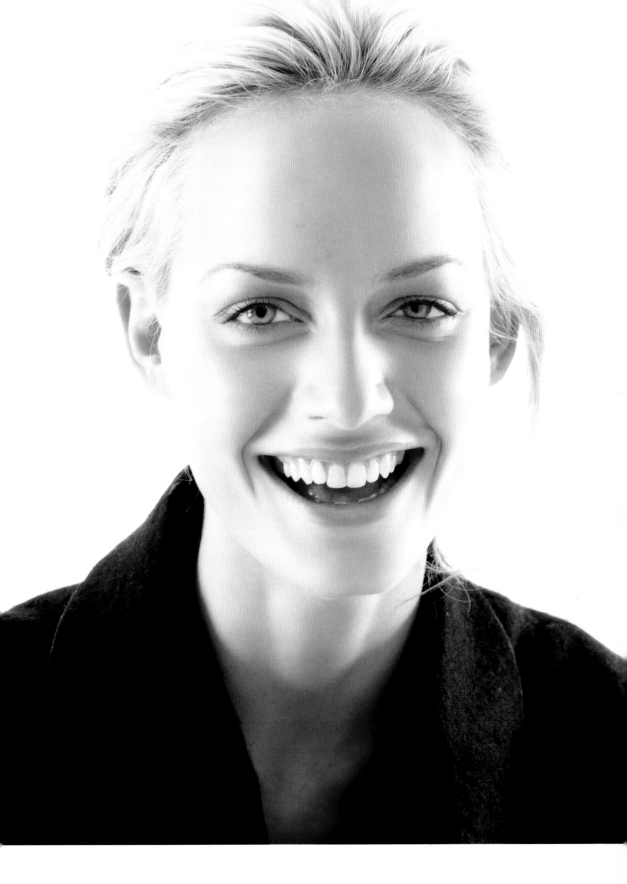

patrick demarchelier / *amber valletta courtesy of harper's bazaar*

CHANGING OF THE GUARD

BY INGRID SISCHY

Often it's when everyone forgets about a subject that something new happens with it. This is exactly what has happened to beauty. For so long, beauty seemed like a closed circle to most of us. In life, in fashion, in art, it had become a matter of formulas —and who's interested in that?

Haven't we all, at one time or another, felt powerless against the tyrannies that can come when standards of being are set up by others and not ourselves? Haven't we all felt an emptiness when something is pointed at, and we're told it's "beautiful," as though it were a command to appreciate it? And yet it doesn't speak to us. Haven't we all been thrilled to the opposite of that numbness when we discovered something or someone beautiful for ourselves?

Hasn't every female felt some pressure to be beautiful in a conventional way, and experienced a sense of inadequacy because she didn't live up to some artificial ideal? Hasn't every male suffered through the equivalent of this setup for an inferiority complex? These are just the tips of the iceberg that make most of us freeze when we hear the word "beauty."

Because tyrannies, hierarchies, and false pressures have so often gone hand in hand with the word "beauty," it has stifling associations. That's what was so liberating about punk. It said screw the formula of what looks beautiful, screw the idea that

music has to act obedient to some notion of beautiful sound. And it made up its own kind of beauty. There's a reason that punk has made such a big comeback in the last few years. There's a reason that a whole new generation of photographers, actors, and models has arrived to say, "We reject the old formulas of what is beautiful." There's a reason that the beauty industry is having to rethink what it is pushing if it is to get people to buy its products. Ideas of beauty needed to change.

Beauty hasn't been seen as big enough to absorb what is really and truly beautiful, and it didn't seem to get with the program in terms of all the recent changes that have gone on in the world. It seemed to be apart from reality. In the last few years, we kept hearing things and seeing things that pointed to a yearning for an expanded consciousness about beauty—but not the old, limited ideas of beauty. We noticed in all sorts of ways that people were expressing a desire to make beauty real. We realized that something really big was up when so many different kinds of things were being called beautiful by younger people, and ugly by those who still subscribed to the old myths of beauty. We realized that there had been a revolution in beauty that paralleled all the other social revolutions that have been such a part of our times.

There is nothing more inspiring than beauty when its chains are taken off. With more of it in the world—which is possible if more of it has a chance to be seen and appreciated— who knows, maybe beauty can work its magic.

ima gine

the
first
woman
who
put
red
on
her
lips...
unthinkable!
the
first
one
with
false
lashes...
crazy!
when
you
consider
the mad
things
that
people
do.

serge lutens

THE
GREEK
WORD
FOR
GOOD
AND
BEAUTIFUL
IS
THE
SAME,
AND
THAT
CONFUSION
HAS
EXISTED
THROUGHOUT
HISTORY.

michelle voyski

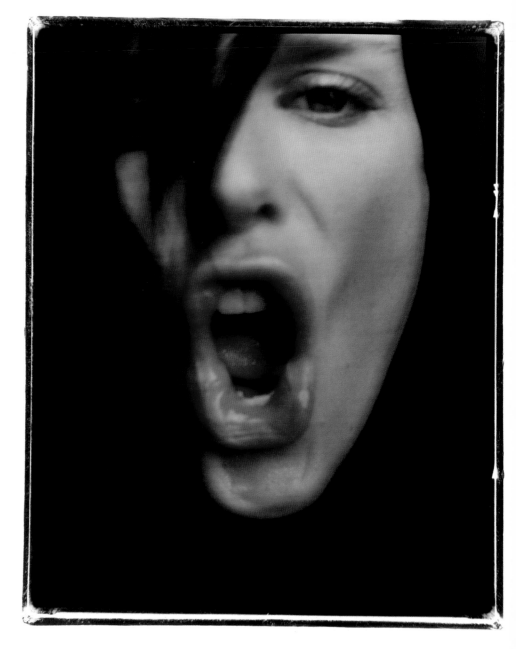

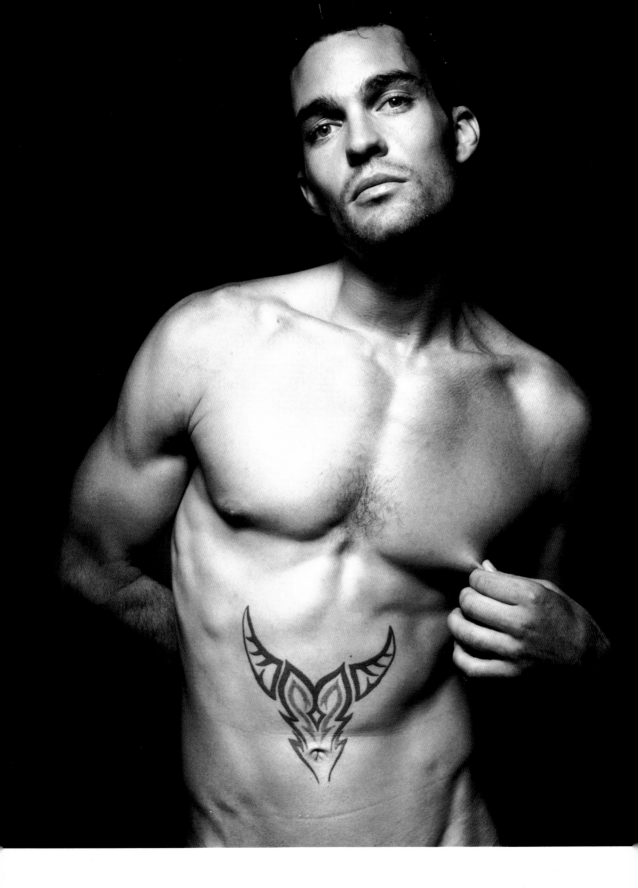

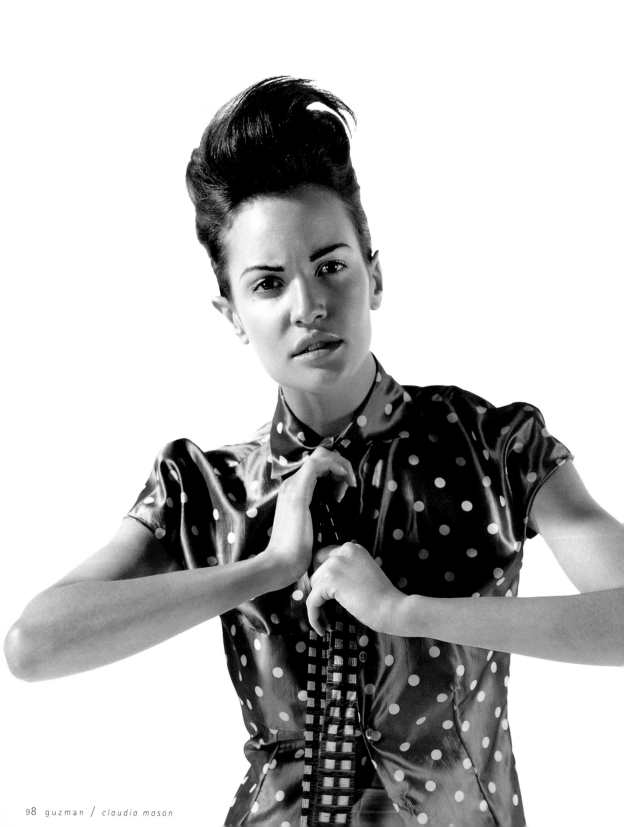

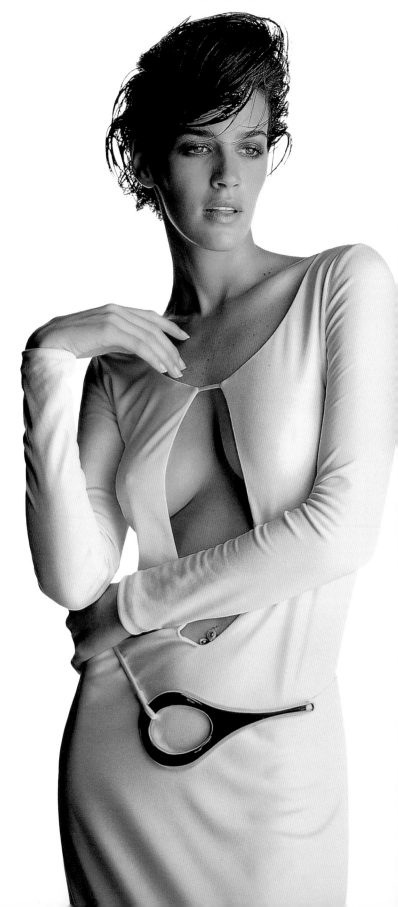

I
HEAR
PEOPLE
SAY,
"OH
THAT'S
VERY
FEMININE,"
OR
THAT'S
MASCULINE."
THE
KIND
OF
WOMAN
WHO
INSPIRES
ME
IS
COMPLETELY
CONFIDENT
AND
BY
THAT
DEFINITION
SOMEWHAT
MASCULINE
IN
HER
SENSE
OF
HERSELF:
VERY
SELF-ASSURED
AND
CAPABLE
OF
MAKING
DECISIONS.
VERY
STRONG,
VERY,
VERY
STRONG
AND
SEXY.

tom ford

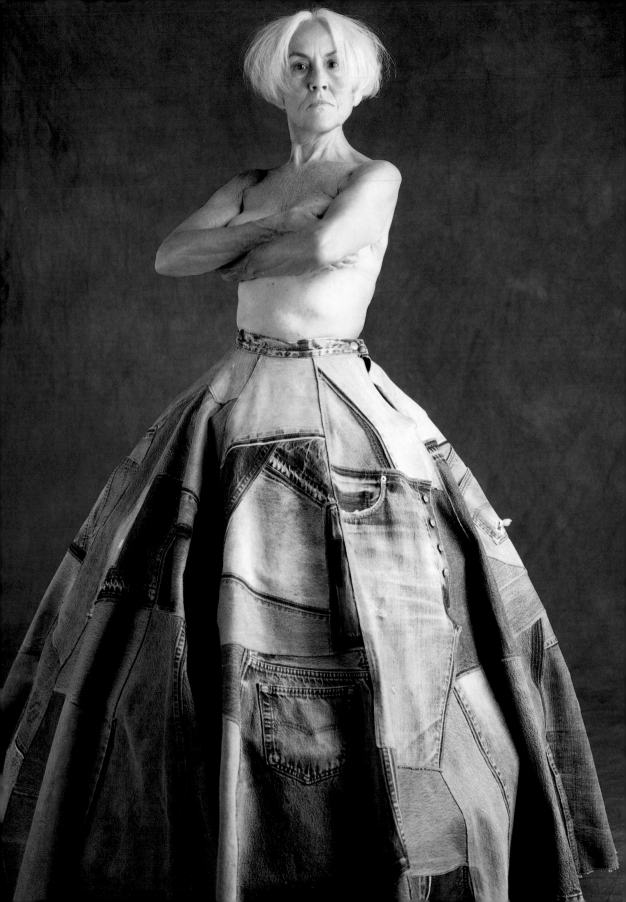

i was doing a series of
portraits of fashion stylists
wearing denim. i asked them to bring
anything they wanted, as long as it
was denim. polly didn't want to do the
shoot at all, but finally showed up—in a
$25,000 Gaultier denim patchwork hoop dress.
she put the dress on and said,

"WHAT
DO
YOU
THINK?"

i said,

"I THINK
YOU
SHOULD
DO
IT
TOPLESS."

she stared at me for what seemed
like a very long time. it was probably four
seconds. then she said, "you're absolutely
right." the shot is very modest, yet absolutely
outrageous. many of her contemporaries
were appalled. polly loved it.

timothy greenfield-sanders

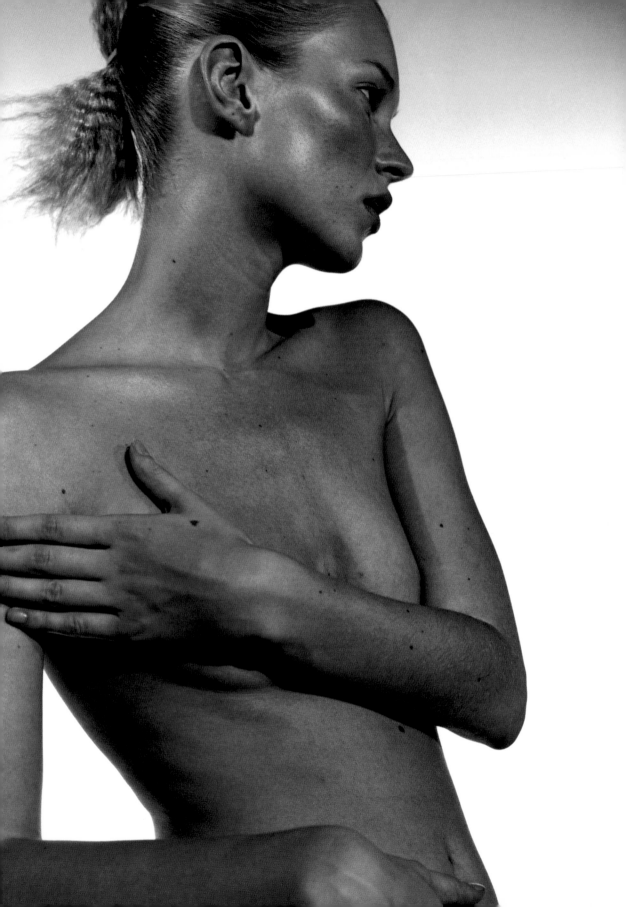

KISS
ME
KATE

BY BARBARA LIPPERT

She has a face like an Egyptian cat: fine-boned, timeless, a bit superior. It's a seductive face that the camera loves, sans makeup. (Perhaps that's why she's one of the few celebrities who looks good with a milk moustache.) Yet when she arrived in the early 90s, a universal shriek went out, as if we were all open-mouthed Munch men grabbing our cheekbones. From the response, you'd think she were Satan herself.

Why do we demonize Kate Moss? Much has been written about waifs as a symbol of feminist backlash: that they suggest female passivity, child sexuality, and even death. Some of the pale, wan, nearly nude portraits of Kate (especially the 1993 ads for Calvin Klein's *Obsession*), shot by her then-boyfriend Mario Sorrenti, did, in fact, conjure up the work of photographer Sally Mann, notorious for taking pictures of her developing children in ambiguous, sexual poses. Like Mann, Sorrenti's photos threaten our ideas of youth and innocence. Maybe the idea of linking the erotic with youth, or death, was what was so upsetting. Moss does have a look that's unearthly and feverish, like a tubercular young woman in a nineteenth-century novel. Wide-eyed and full-lipped, Kate's face is part Emily Dickinson in the 1860s and part Mick Jagger in the 1960s.

Perhaps, too, we demonize Kate because we can't define her. For *Obsession*, she was a sea urchin, and an Egyptian goddess, posed with one breast exposed. For the 1996 Versace campaign, shot by Richard Avedon, she's a curly-haired lamb in vixen's clothing, a wild woman with meat on her bones, but still an alien creature.

Maybe what's really at the root of the outcry is her failure to conform to our most modern standards of sexual beauty. Her thinness comes from her gene pool, not the *Nordic Track*. She messes with our belief in possibility—she aggressively avoids working at self-transformation. Her pale body is soft, unformed, not buff. And she has also resisted the knife: she sports her own small, natural breasts, as opposed to the larger, harder, soccer-ball variety that is still so in vogue. If she had gotten implants, as have so many models, would detractors still be screaming about anorexia and eating disorders? Because the so-called healthy "glamazons" were, in fact, Barbies come to life: impossibly long-legged, slim-hipped creatures with huge gozongas.

Perhaps the most epochal picture of Kate is the *Obsession* shot where she's lying bare-bottomed on a big grungy sofa. Even here, a scene that could simply be sordid is brought to life by the alchemy of her body at rest and the unspoken challenge of her gaze. Naked, there—yet strangely absent—in her Garbo-like retreat.

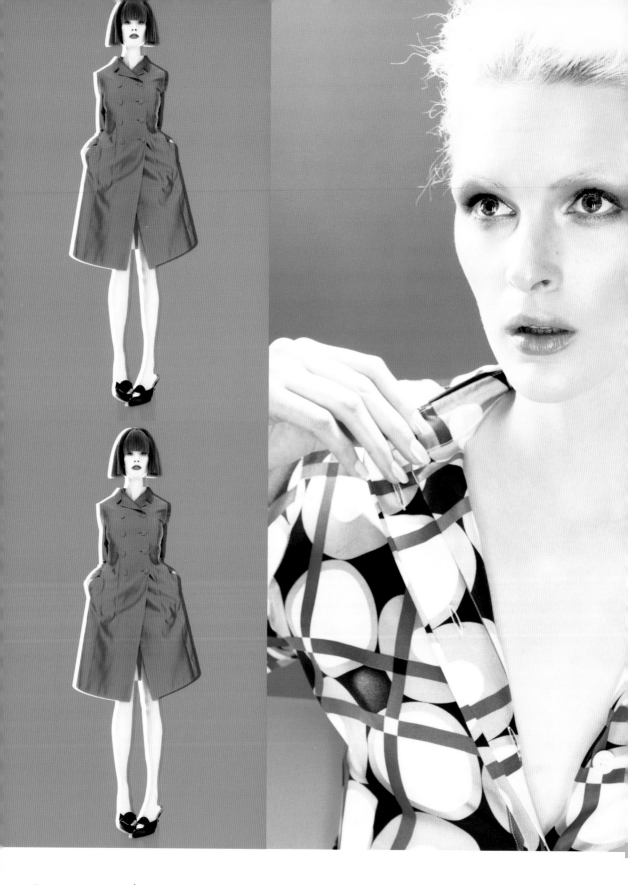

I CAN'T IMAGINE WHAT A WOMAN WILL BE LIKE TEN OR TWENTY YEARS FROM NOW. WHAT I AM DEFINITE ABOUT IS THAT OTHERS SHOULD NOT DICTATE WHAT IS FEMININE.

serge lutens

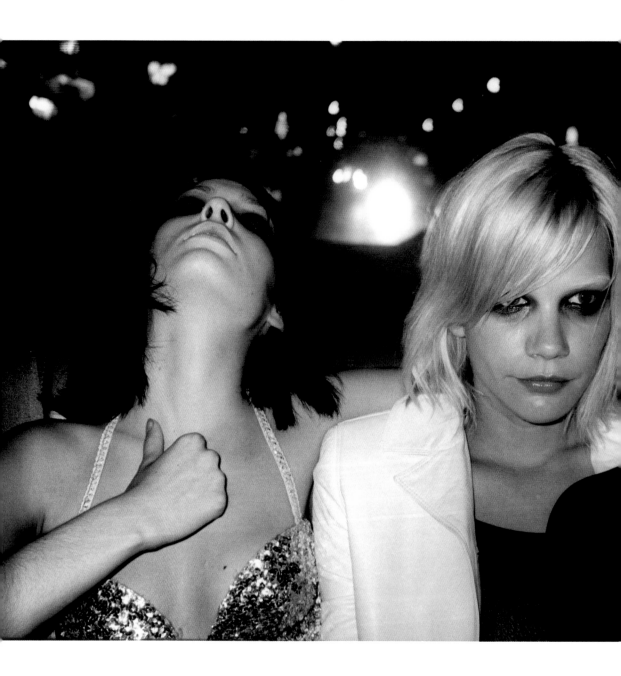

BEAUTY TODAY IS ABOUT STANDING OUT RATHER THAN BEING CLASSIC, EACH PICTURE IS ABOUT MAKING A

A FEMININE SIDE, AND WHEN BOTH SIDES ARE EXPRESSED, I FIND IT BEAUTIFUL AND FASCINATING.

jean-paul gaultier

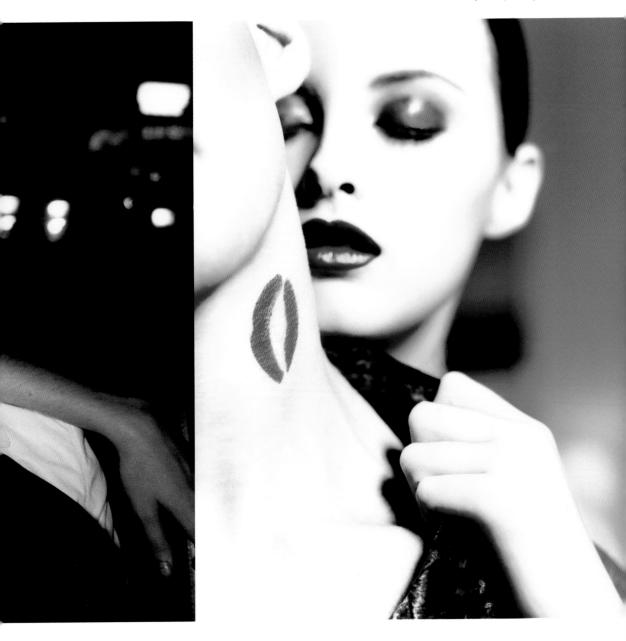

SPONTANEOUS MOMENT—GETTING PEOPLE TO DO THINGS THEY WOULD NEVER DREAM OF DOING.

elizabeth saltzman

I
HAVE
TROUBLE
WITH
THE
"WORD"
"BEAUTY." most media images you see today have
nothing to do with beauty. they're more about attitude.
they send up a message that says: she's sultry, or sexy,
or abandoned. or vapid—that's a term that comes to
mind a lot. but beautiful?

just as attitude has gained sway over beauty in looks,
fashion-of-the-minute has gained sway over style in
clothes. the question has become: what's going to
attract media attention *now*? the market is driven by
that question more than it has ever been.

grace mirabella

COOKIE-CUTTER WOMEN FORSAKE THEIR PERSONAL BEAUTY
FOR
IMAGES REPRESENTED BY MODELS
WHO PASS US BY AS
QUICKLY AS TRENDS DO.

norma kamali

when i was
growing up,
beauty was
all about
tall, thin,
blonde, and
white. my
models were
cheryl tiegs,
christie brinkley,
and barbie. TODAY, BEAUTY IS
A MUCH MORE ECLECTIC
COLLECTION OF
FEATURES AND COLORS.

bobbi brown

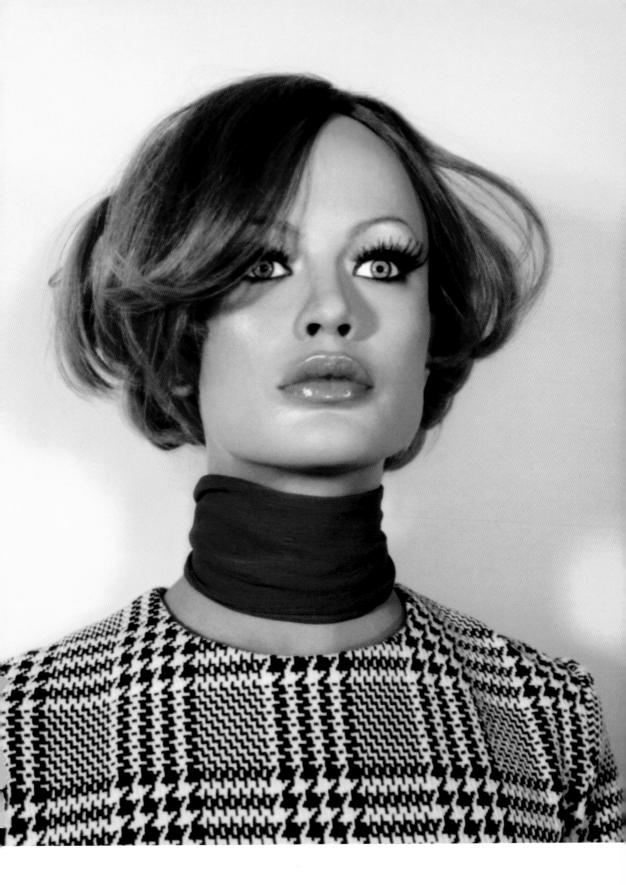

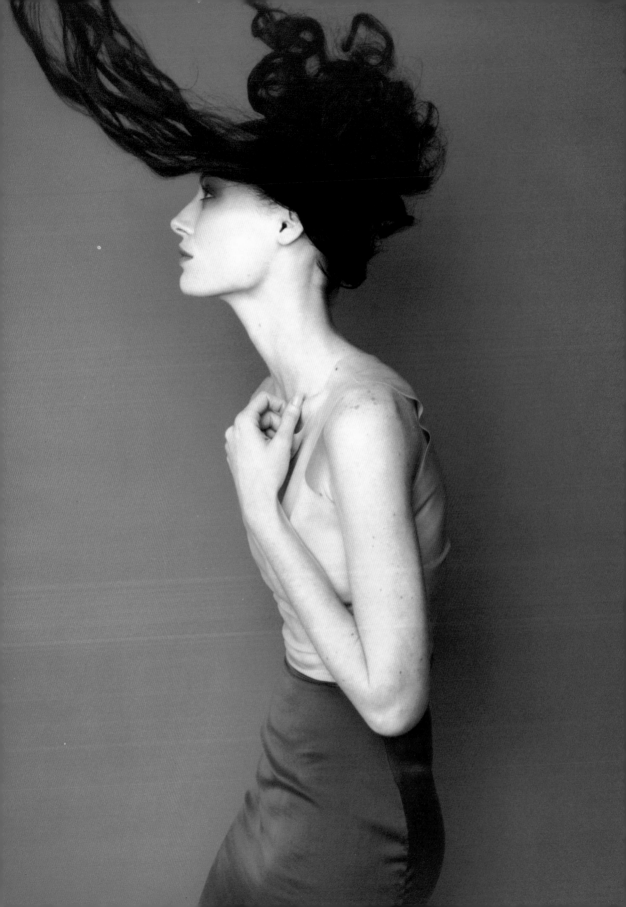

DANCING ON THE EDGE

BY RICHARD BUCKLEY

Edge is a 90s synonym for hipness. As the last word in contemporary chic, edge can be defined as a cynical, slightly pessimistic, and decidedly "in-your-face" attitude that has permeated all aspects of our present-day culture. As such, it has also become the most all-encompassing and longest-lasting fashion phenomenon of the decade.

It almost seems quaint, by today's standards, to think that being on the edge was once a term used to describe people or things considered to be avant-garde or on the outside of established society. The word counterculture, for example—only coined in 1968—has become anachronistic. What was once considered cutting-edge and underground is now so absorbed into the mainstream that the trappings of cool can be bought as easily by rock stars as mall rats. Looking at the current editorial or advertising pages of fashion magazines, edginess has become just another marketing tool for selling clothes, beauty, and music. In essence, it has lost its edge.

Various subcultures in the twentieth century have employed unconventional clothes, hairstyles and music as subversive symbols or codes to identify members of their group, and to challenge society's established rules of dressing and perceptions of beauty. At the beginning of this decade, grunge in America and deconstructivism in Europe were fashion's way of questioning 80s excesses: conspicuous consumption, preppie wholesomeness, and designer-fueled notions of elegance. While the fashion objective of the 80s was to make people look pulled together, successful, and in control, grunge and deconstructivism repudiated those former notions of propriety. This simultaneously corresponded to changes in the culture that—in a complete turnaround—had become less obsessed with materialism and had begun to take a colder, harder and more cynical look at itself. This aesthetic in turn manifested itself in images, films, and books that were not only pessimistic but appeared to embrace chaos and disorder.

The simplicity, directness, and rejection of ostentation in grunge and deconstructivism resulted in a new look that could best be described as anti-fashion. In a way, clothes, hair, and makeup have taken on a form of self-protection from the affronts of the modern world. Looking disheveled, bored, and slightly threatening is like putting on a tough exterior that says, "Don't bother me."

The gritty pictures of a core group of British photographers—Corrine Day, Mario Sorrenti, Glen Luchford, and David Sims—offered a new fashionable take on the unflinchingly stark subject matter of documentary photographers like Larry Clark and Nan Goldin. This kind of studied edginess, however, becomes as contrived as that which it set out to destroy, and perhaps is even less honest. It simply trades one form of posing and consumerism for another.

Fashion and beauty are outward manifestations of an inner need we have to express and reinvent ourselves. They also enable us to redefine the borders between ourselves and our culture. Anti-fashion is, ultimately, not fashion at all, since it has become just another trend which has nothing to do with individual style. Perhaps the real definition of "cutting-edge" is to be found in the ability to take the kind of personal risks that ultimately push our society forward.

BOYS GIRLS AND THE (BEAUTY) GENDER GAP

BY NANCY FRIDAY

I know from firsthand experience what it is like to grow up without beauty in a family that has it in abundance. As a southern girl, I was everything I shouldn't have been: too tall, flat-chested, a leader, athletic—not soft. My sister was, literally, a beauty queen. She looked like my mother. And my mother could not perceive me as beautiful. I remember once being on a trip to New York with my mother and her friend, and the friend said, "You know, I think Nancy's becoming better looking than Suzy." And my mother said, "What?" She didn't see it.

Women who have mothers who didn't see their beauty, always live with that knowledge. Every time you look in the mirror, you see yourself as your mother saw you.

So when sexual beauty arrived, late in adolescence, it was such a powerful force, I gave myself over to it completely. Sexual beauty is what every girl wants more than anything during adolescence, because that most desirable commodity, the boy, is naturally drawn to it. She of the perfect number of centimeters between her nose and eyes, she of the full breasts and wide hips, who can carry forth his line —it is she who will prevail.

By comparison, the beauty we see in magazines today is abstract, asexual. Many of these women are indeed anorexic; certainly most of them look it. When you're anorexic, you often stop bleeding, you cannot produce a child. Is that sexual beauty? I don't think so. We are, however, so used to this representation of woman, we think of her as desirable. Do men? Or has it gone so far that men simply see today's model icon as a trophy? Where then, I would ask, does this leave sexual imagery? Or to put it more bluntly, where does it leave sex between men and women?

It's a confusing time for a woman who looks for her sexual self in her mirror, or in her mind's eye. Is she supposed to be like the ideals she sees in magazines, or should she have full hips, breasts, fleshiness? I see a correlation between young women's worries about their sexual beauty and the increased number of women who report having sexual fantasies about being with another woman. It is the most popular theme of younger women's fantasies today.

Women have always worried about their sexual beauty, meaning they have walked a fine line between celebrating and hiding it. We still do. We fear other women's judgment. Our yearning to be sexually desirable is tempered by the dread of walking into a room, seeing the women putting their heads together, whispering, "Doesn't she look like a slut?" What we long for is to hear women say, "Doesn't she look wonderful?" and simultaneously to feel men's sexual desire for us. That is a fantasy yet to be realized.

the way our features are flung together is just an accident. i mean we all hav

TWO
EYES,
...they're just arranged differently. *elizabeth taylor*

A NOSE,
AND
A MOUTH

MY WHOLE NATION IS GRACEFUL. NOBODY HAS TO TELL US HOW TO WALK OR HOW TO STAND. we have dignity.

WHATEVER HAPPENS, YOU KEEP YOUR HEAD UP.

i m a n

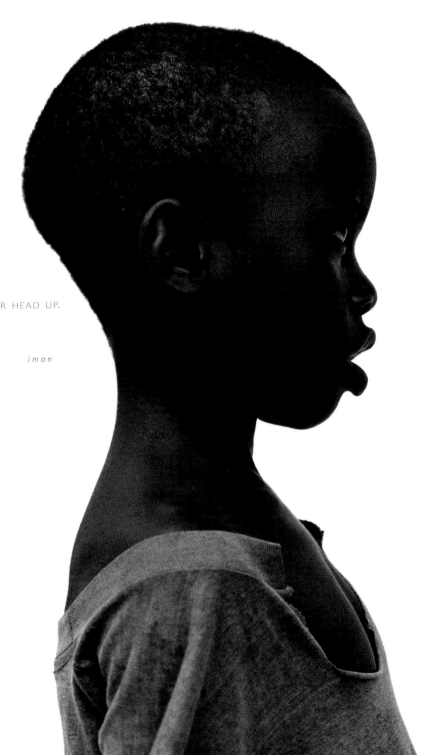

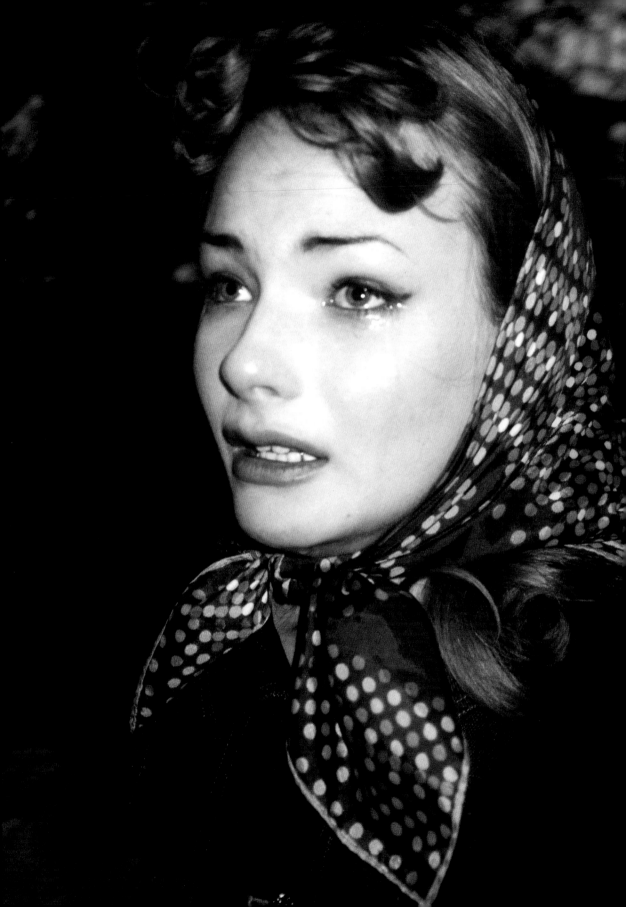

if i
get
attached
to a
person,
within
three
weeks
i start
to
see
him
or
her
as

beau
tiful

...when a
person
shows
emotion,
then
immediately
i'm
susceptible
to that
person's
beauty.

isabella rossellini

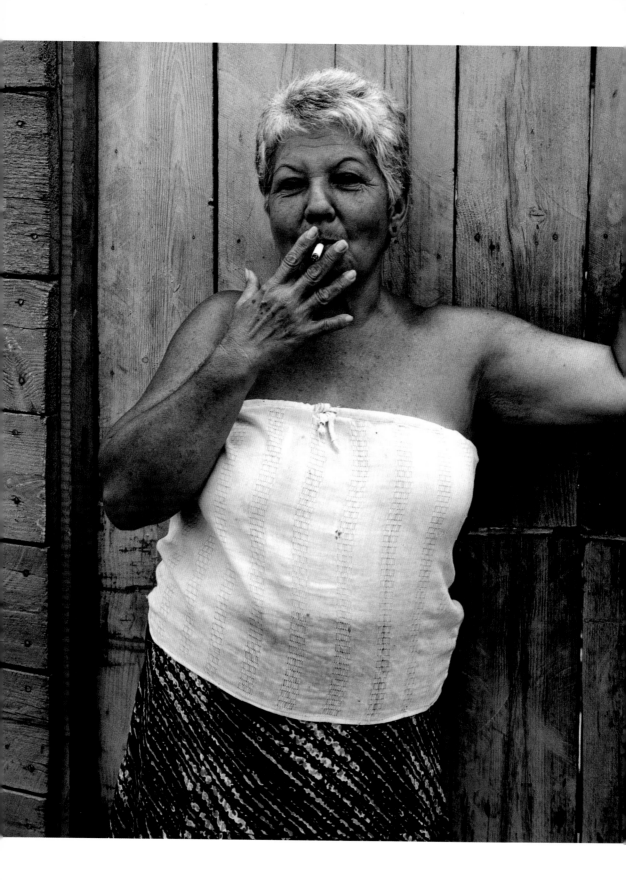

when
i first
started
out,
i wanted
everyone's
approval.
but as
you
mature,
you
realize

EVERYONE
DOESN'T
HAVE
TO
LOVE
YOU.

paulina porizkova

my mother was a seamstress.
i grew up watching women
sew clothes, seeing beautiful
work being done. my mother
would make me a dress and
say, "you like it, but
don't fall in love with
it because EVERYTHING
CHANGES
IN,
LIFE."

donatella versace

MY DEFINITION OF BEAUTY: KNOWING ONESELF AND ALWAYS BEING ONESELF. NOT HIDING YOUR TRUE SOUL FROM THE WORLD IN SOME CLOSET. PRIDE NOT SHAME. TRUTH NOT FEAR.

kevyn aucoin

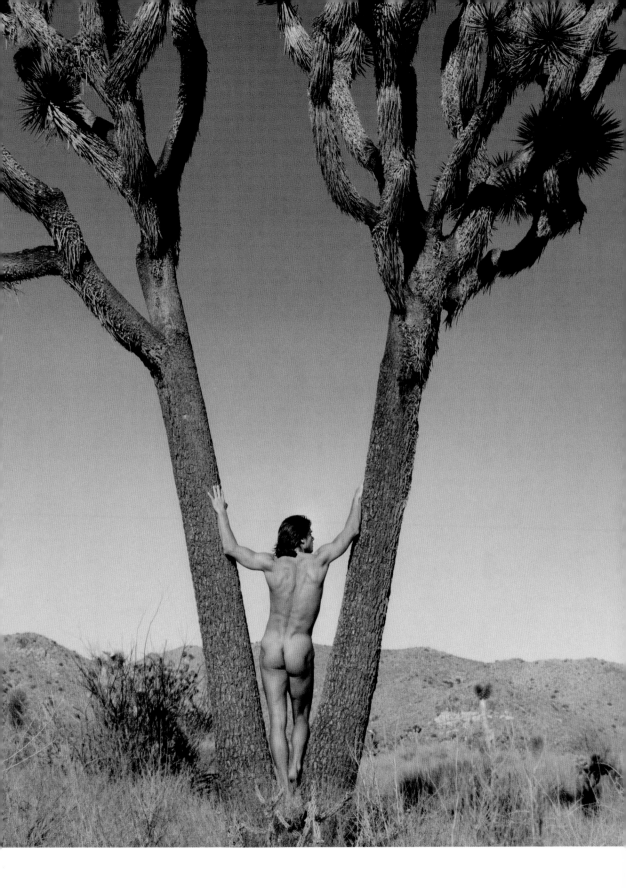

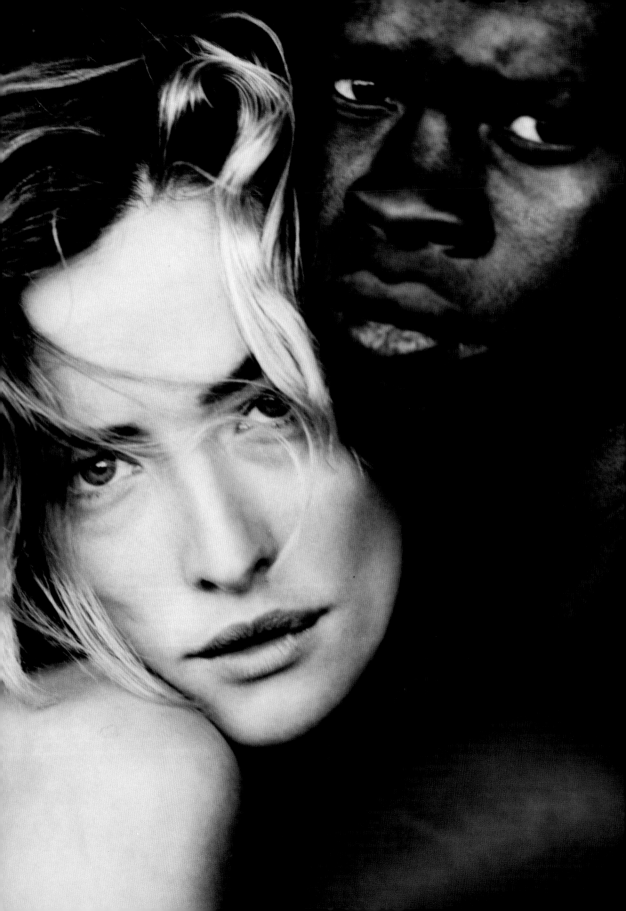

WHAT IS BEAUTY?

HERE'S AS MUCH AS I KNOW:

IT'S NOT NEARLY AS RARE AS WE'VE BEEN LED TO BELIEVE.

IT TURNS UP IN THE MOST SURPRISING PLACES.

IT'S AT ITS MOST SUBLIME WHEN IT'S UNAWARE OF ITSELF.

IT IS NOT A FUNCTION OF YOUTH OR A SMALL NOSE OR THIN THIGHS.

THOSE WHO LIVE THEIR LIVES IN PURSUIT OF IT ARE DOOMED.

IT COMES IN TWO VARIETIES: THE INSTANT-IMPACT TYPE AND
THE SLOW, TIME-RELEASE KIND.

IN MEN, IT GOES BY THE NAME OF HANDSOMENESS,
SO AS NOT TO GIVE OFFENSE.

YOU'LL KNOW IT WHEN YOU SEE IT.

holly brubach

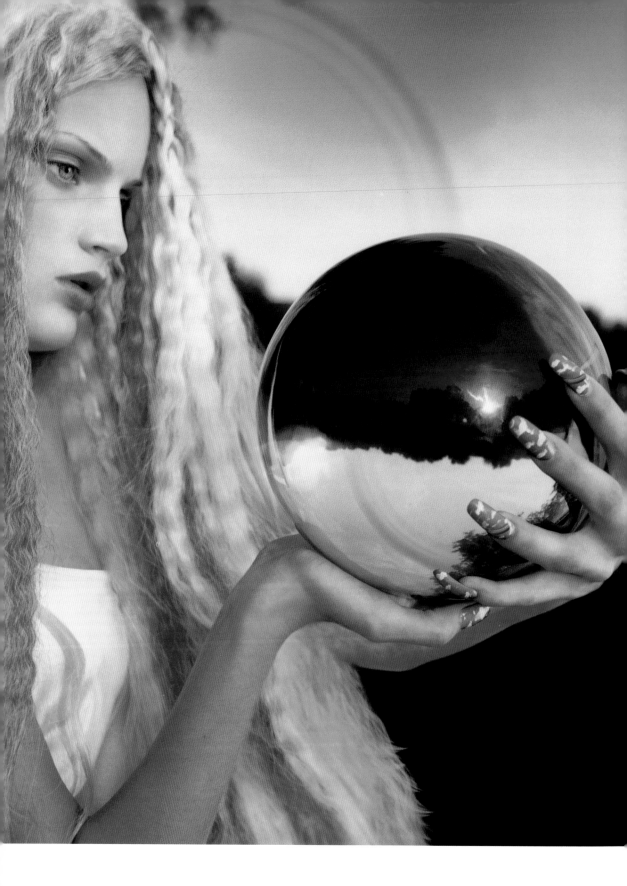

IT'S TOO OPPRESSIVE TO PRESENT JUST ONE IDEA OF BEAUTY...
THAT THERE'S ONLY ONE SET OF "RIGHT" GENES.

michael musto

bias towards beauty is a
bias against those who
lack it. as with other
kinds of prejudice, change
can come only after we
recognize it for what it is.

melvin konner

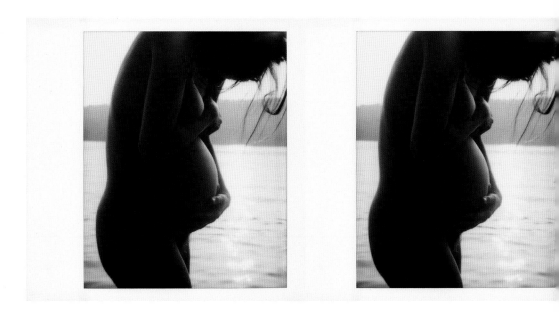

IF YOU CAN LEARN TO LIKE HOW YOU LOOK—AND NOT THE WAY YOU THINK YOU LOOK—

it
can
set you
free.

gloria steinem

EVEN A HOPTOAD IS BEAUTIFUL TO ITS MOTHER.

paul sorvino's mother

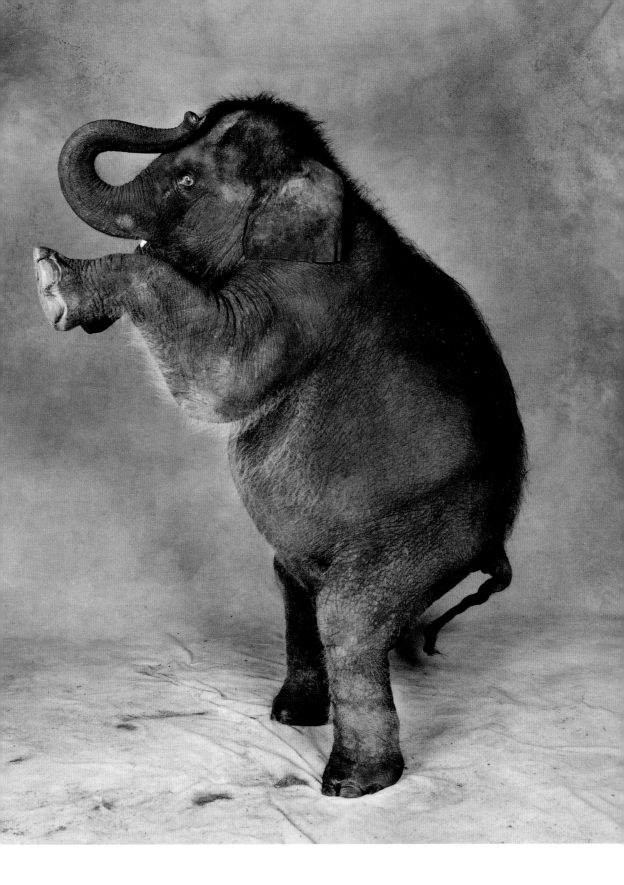

WHY I WEAR PURPLE LIPSTICK

BY JEAN GODFREY-JUNE

Beauty trends arise for exactly the same reasons that a boot-cut pant, a maxi coat, or an unexpectedly chunky heel induces in many of us that pre-verbal, hunter/gatherer, foaming-at-the-mouth, let-me-at-it lust for the new, the different. We're bored, we long to reinvent ourselves, to shake things up. It's that little bit of Madonna in everyone that says to the world, "Thought you had me all figured out? HA!"…and moves on.

Many—but certainly not all—beauty trends emerge backstage at fashion shows, as makeup artists and hairstylists interpret what a given designer has done with the clothes that season; as the models travel from one show to the next (often with ten minutes in between), their faces transmit the last show's news to the team working on the next one. If it's modern, if some aspect of it applies to the show at hand, it's taken up, adapted, and further cemented as "The Look of the Season," be it darker lips, slicked-back hair, or baby-blue toenail polish.

Beauty trends are rarely about being beautiful. At ground zero, they're about shock, daring, imagination: Being first on the block to wear a green-grey nail polish called "Mildew," or to try the new "skunk stripe" highlights before anyone else does requires serious cojones, or at the very least, a love of the spotlight.

Being second or third on the block involves the opposite impulse. Like a secret handshake between a clique of nine-year-old girls, a gloss of pink-frosted lipstick, or a barrette pinned just so signifies membership, belonging. With beauty products, this second stage of a trend can take on an evangelical tone, as the first-wave "pioneers" convert their friends and associates.

How one wears one's hair and exactly what shade of lipstick one selects is, in the grand scheme of things, silly, useless information. Silly and useless in the same way that one prefers a certain vintage from a particular vineyard, or grills one's vegetables just so. It's about pleasure, choices, and changes—the little ones that make us human.

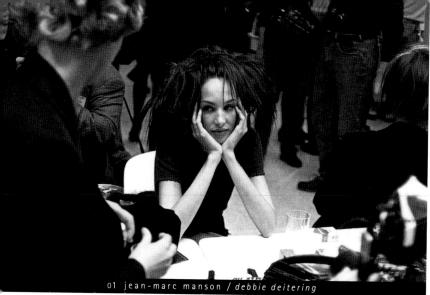

01 jean-marc manson / *debbie deitering*

YOU
THINK
I AM
BEAUTIFUL

I LOOK BEAUTIFUL
THEN I AM BEAUTIFUL.

BEAUTY IS GRACE, A LIGHT IN THE EYE,
PERFECTION OF CHEEK AND BROW,
THE TURN OF THE HEAD.

AND ALL OF THIS DEPENDS ON/IS INVENTED
AND INVESTED WITH THE SKILL AND VISION
AND LOVE OF THOSE "BEHIND THE SCENES,"
WHO NOT ONLY WORK WITH
THE DESIGNER OR PHOTOGRAPHER,
BUT WHO LIGHT THE FIRE OF BELIEF
IN ALL THOSE WHO MUST ENACT
AND EMBODY THE DREAM.

WITHOUT THE DREAM-MAKERS,
WHERE WOULD WE BE?

john galliano

02 jean-marc manson / *john galliano*

BEAUTY IS MORE
ILLUSION THAN REALITY.

carolina herrera

THERE IS NO COSMETIC
FOR BEAUTY LIKE HAPPINESS.

countess of blessington
1789-1849

03 jean-marc manson / *claude montana*

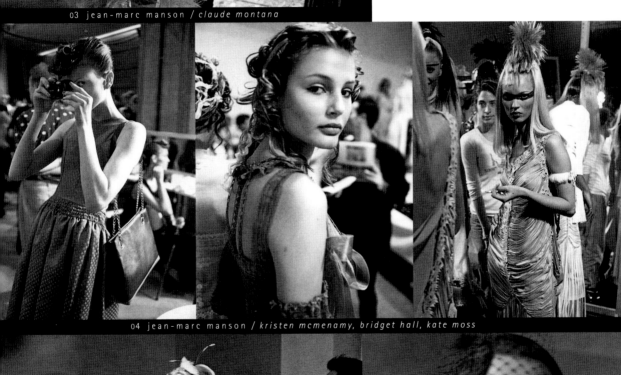

04 jean-marc manson / *kristen mcmenamy, bridget hall, kate moss*

TO BE
BEAUTIFUL
AND NATURAL IS
THE BIRTHRIGHT OF
EVERY WOMAN.

Elizabeth Arden
1880-1966

06 deborah turbeville / *paul sinclaire, elana blau*

I STILL LIVE WITH OUR NEWEST
MODELS, BECAUSE NO ONE
ELSE WOULD DO IT. I'VE GOT
SEVEN OF THEM WITH ME NOW.
HOW WOULD YOU LIKE TO LIVE
WITH SEVEN TEENAGERS, SEVEN
DAYS A WEEK? IT'S LIKE HELL
ON EARTH.

eileen ford

07 deborah turbeville / *sam mcknight*

WHEN
I PHOTOGRAPH A
WOMAN, I LIKE TO
SEE THE TENSION
BETWEEN SOME
QUALITY THAT IS
HEALTHY AND VIBRANT
AND MODERN, AND
SOMETHING ETERNAL
AND INFINITE.

sheila metzner

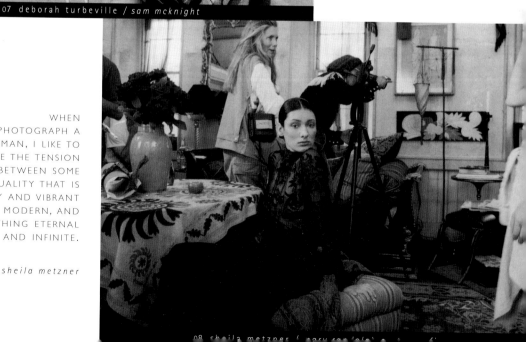

08 sheila metzner / *gary son'ola*

BEAUTY IS A FORM OF
SELF-EXPRESSION.
IT'S ABOUT THE
FREEDOM TO CHANGE.
THIS IS A VERY EXCITING
TIME BECAUSE LOOKS
AREN'T BEING CREATED
BY RUNWAY EXPERTS;
THEY'RE COMING
FROM THE STREET.

john sahag

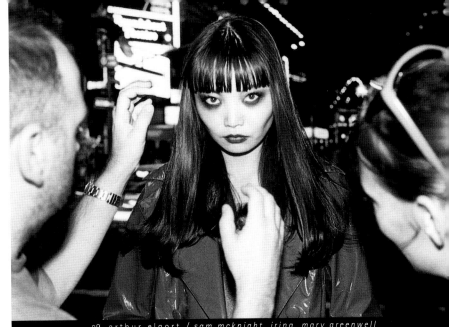

09 arthur elgort / *sam mcknight, irina, mary greenwell*

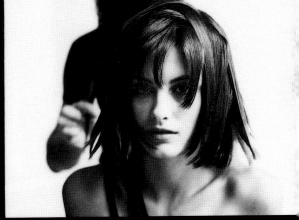

10 arthur elgort / *phyllis posnick, trish goff, john sahag, dick page*

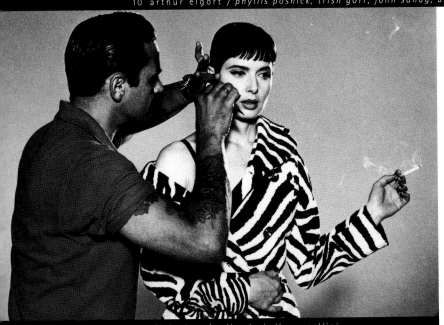

WHAT YOU
STAND FOR
GOES WAY
BEYOND
SELLING
MASCARA...

isabella rossellini

WHAT'S
BEAUTIFUL
TO ME IN
PHOTOGRAPHS,
IS SOMEONE WHO'S
WILLING TO BE OPEN
AND HONEST IN
FRONT OF THE CAMERA...
SOMEONE WHO'S
WILLING TO TAKE
A CHANCE.

herb ritts

HAIRSTYLE
IS THE
FINAL
TIP-OFF
WHETHER
OR NOT
A WOMAN
REALLY
KNOWS
HERSELF.

hubert de givenchy

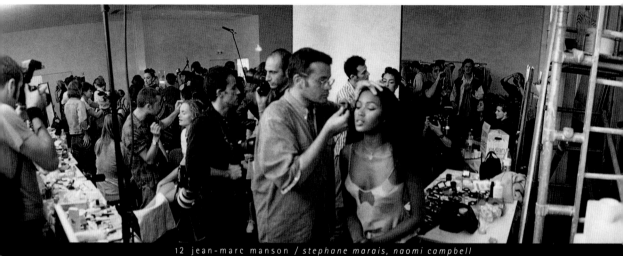

12 *jean-marc manson / stephane marais, naomi campbell*

MY JOB IS TO
CREATE THE TOOLS
TO MAKE THE WHOLE
PROCESS LESS TEDIOUS.
AFTER ALL, WHEN YOU
DRESS IN THE MORNING,
IT'S A BORE. YOU GET
UP AND SPEND ALL
THAT TIME FIXING
YOURSELF UP, YET AT
THE SAME TIME YOU
WANT TO BE
COMFORTABLE.

diane von furstenberg

I'VE FELT A
RESPONSIBILITY
TO DEMONSTRATE
THAT BEAUTY
DOESN'T COME
IN ONLY ONE
SHAPE OR SIZE.
BEAUTY COULD
BE A SEVEN-FOOT
BLACK MAN IN DRAG.
OR IT COULD BE
A WOMAN LIKE
K.D. LANG, WHO
WEARS NO
MAKEUP AT ALL.

frank toskan

13 *courtesy of m a c / rupaul k.d.*

THERE ISN'T FASHION
WITH OUT THE PAST.

isaac mizrahi

IT'S SICK
TO DIG
OUT LOOKS FROM
THE TIME
MACHINE
WHEN WE'RE
LIVING
IN SUCH AN
EXCITING
PRESENT.

helmut lang

THERE'S SO MUCH
TALK ABOUT EACH
SEASON'S TREND.
I BELEIVE THE ROLE
OF THE DESIGNER
SHOULD BE TO
ENCOURAGE
INDIVIDUALITY.

marc jacobs

14 jean-marc manson

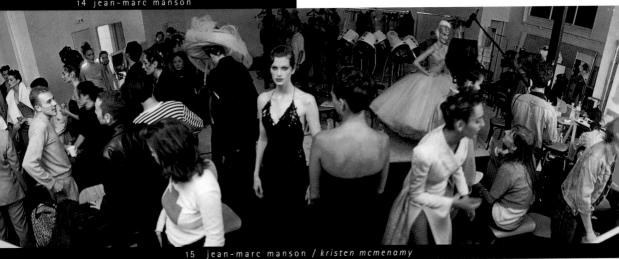

15 jean-marc manson / *kristen mcmenamy*

BEAUTY IS AN
EMOTION. AND
WHAT'S WONDERFUL
IS IT'S PERSONAL.
EVERYONE HAS THEIR
OWN VISION OF IT,
NONE BEING THE SAME.

pamela hansen

FASHION IS A
FORM OF UGLINESS
SO INTOLERABLE
THAT WE HAVE
TO ALTER IT EVERY
SIX MONTHS.

oscar wilde
1856-1900

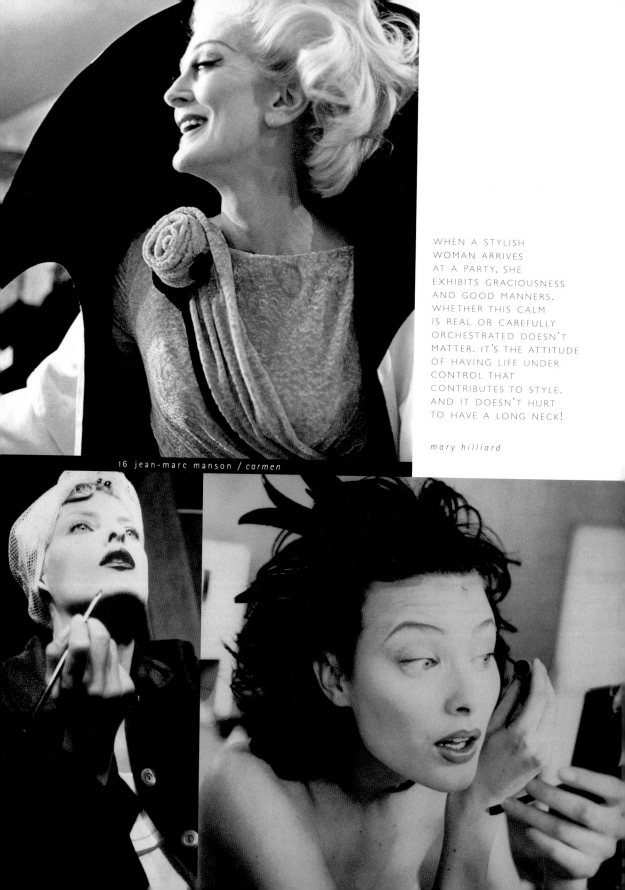

WHEN A STYLISH
WOMAN ARRIVES
AT A PARTY, SHE
EXHIBITS GRACIOUSNESS
AND GOOD MANNERS.
WHETHER THIS CALM
IS REAL OR CAREFULLY
ORCHESTRATED DOESN'T
MATTER. IT'S THE ATTITUDE
OF HAVING LIFE UNDER
CONTROL THAT
CONTRIBUTES TO STYLE.
AND IT DOESN'T HURT
TO HAVE A LONG NECK!

mary hilliard

16 jean-marc manson / carmen

19 jean-marc manson / *veruschka*

IS THERE GREAT STYLE NOW? WE HAVE A
FEW FADS THAT ARE SOMETIMES
PECULIAR, SOMETIMES INTERESTING,
BUT SELDOM BEAUTIFYING. NOW I SEE
WOMEN ADOPTING STYLES THAT SHOULD
ONLY BE ON RUNWAYS. SOMETIMES I
THINK PHOTOS IN MAGAZINES SHOULD
COME WITH THE WARNING: DO NOT TRY
THIS AT HOME.

pablo manzoni

IN THE 60s AND 70s, POPULAR CULTURE
WAS INFUSED WITH THE SENSE THAT
YOUTH COULD RULE THE WORLD.
"DO YOUR OWN THING" BECAME THE CRY
OF THE DAY. BUT TODAY, NO ONE KNOWS
WHAT THAT "THING" IS. HALSTON SAID
THAT HE NEVER CREATED ANYTHING—
HIS CUSTOMER LED HIM TO THE NEXT
STEP OF HIS DESIGN. TODAY THERE
AREN'T ENOUGH PEOPLE WITH
STRONG INDIVIDUAL STYLE.

kenneth

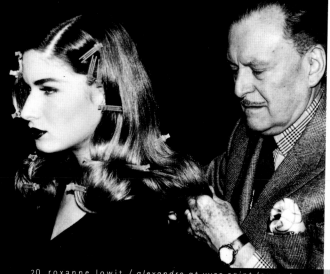

20 roxanne lowit / *alexandre at yves saint laurent*

I'M NOT ULGY BUT MY BEAUTY
IS A TOTAL CREATION.

tyra banks

IT'S A COLLABORATION BETWEEN THE
PHOTOGRAPHER AND THE HAIR AND MAKEUP
PEOPLE. I'M THE END RESULT OF THEIR WORK.

naomi campbell

I LIKE A WOMAN WHO IS CLASSIC,
BUT HAS AN EDGE TO HER...
MAYBE SORT OF ANDROGYNOUS.

garren

BEAUTY IS VERY SUBJECTIVE.
IT'S NOT ABOUT PERFECT FEATURES.
IT'S MORE ABOUT A SENSE OF WELL-BEING.

bobbi brown

TODAY, WOMEN WANT EVERYTHING FAST...
THEY'RE MORE REALISTIC. THEIR GOALS HAVE
CHANGED. MODELS ARE NOT PICTURE-PERFECT
AS THEY WERE IN THE PAST. IN FACT, "PERFECT"
DOESN'T EXIST ANYMORE BECAUSE THE
STANDARD HAS BROADENED.

trish mcevoy

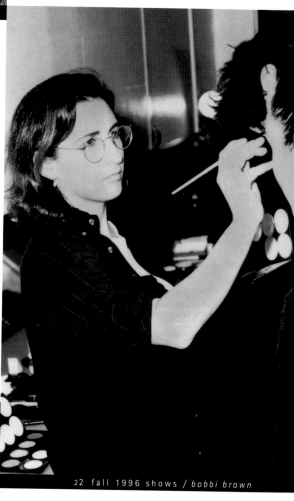

22 fall 1996 shows / *bobbi brown*

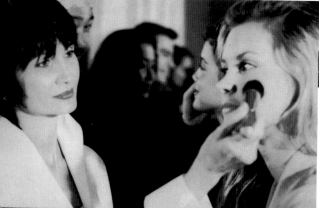

21 tamara leuty / *trish mcevoy, bonnie summerville*

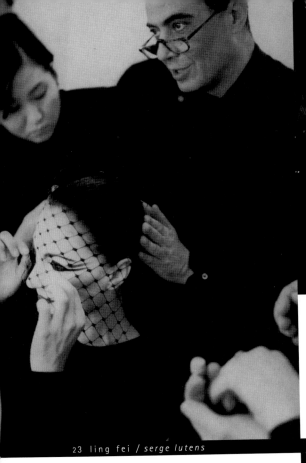

25 roxanne lowit / sam mcknight, nadja auermann

I DO NOT GIVE AN
IDENTITY TO A PRODUCT.
I LEAVE IT TO A WOMAN
TO BRING HER OWN
IDENTITY TO IT.

serge lutens

23 ling fei / serge lutens

WHAT WE DO IN FASHION IS SHOW AN EXTREME. IN
REAL LIFE, WOMEN NEED TO FIND A BALANCE.

francois nars

HE'S A GENIUS. HE'S HEAVEN. HE'S DIVINE.
HE'S ALWAYS LATE.

*madonna
on francois nars*

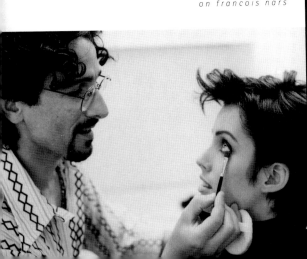

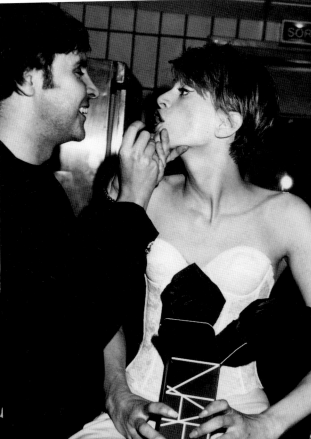

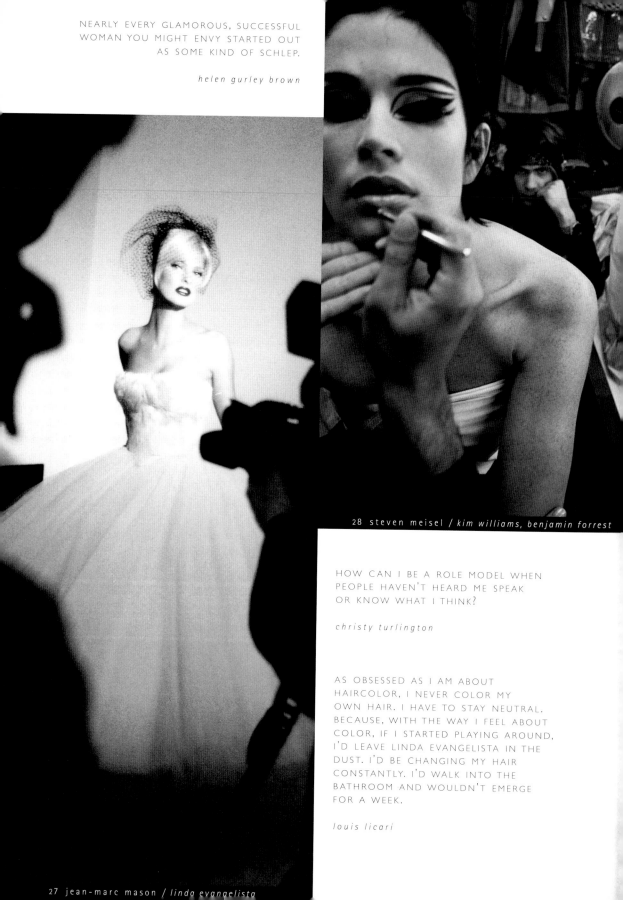

NEARLY EVERY GLAMOROUS, SUCCESSFUL
WOMAN YOU MIGHT ENVY STARTED OUT
AS SOME KIND OF SCHLEP.

helen gurley brown

28 steven meisel / *kim williams, benjamin forrest*

HOW CAN I BE A ROLE MODEL WHEN
PEOPLE HAVEN'T HEARD ME SPEAK
OR KNOW WHAT I THINK?

christy turlington

AS OBSESSED AS I AM ABOUT
HAIRCOLOR, I NEVER COLOR MY
OWN HAIR. I HAVE TO STAY NEUTRAL.
BECAUSE, WITH THE WAY I FEEL ABOUT
COLOR, IF I STARTED PLAYING AROUND,
I'D LEAVE LINDA EVANGELISTA IN THE
DUST. I'D BE CHANGING MY HAIR
CONSTANTLY. I'D WALK INTO THE
BATHROOM AND WOULDN'T EMERGE
FOR A WEEK.

louis licari

27 jean-marc mason / *linda evangelista*

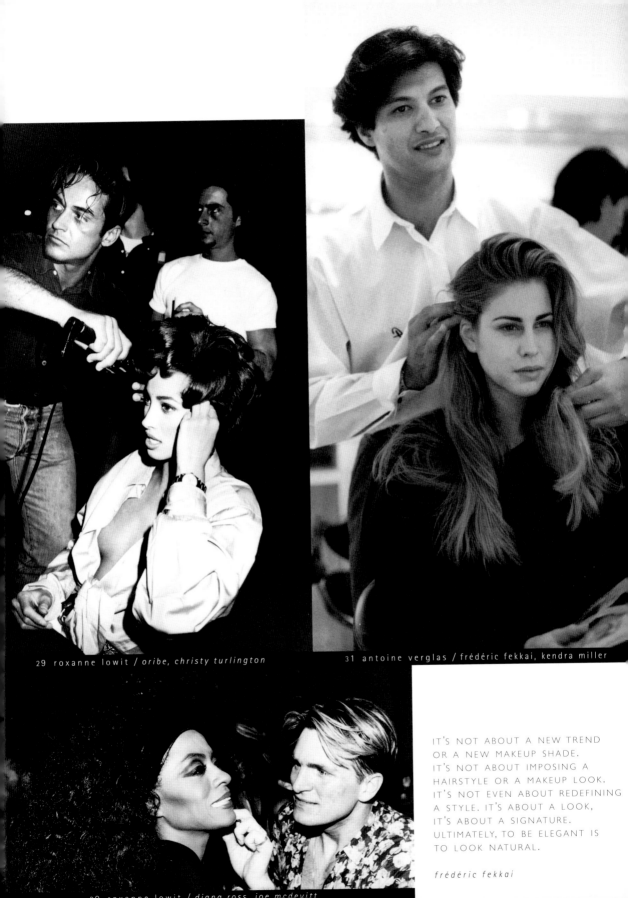

29 roxanne lowit / *oribe, christy turlington*

31 antoine verglas / *frédéric fekkai, kendra miller*

30 roxanne lowit / *diana ross, joe mcdevitt*

IT'S NOT ABOUT A NEW TREND
OR A NEW MAKEUP SHADE.
IT'S NOT ABOUT IMPOSING A
HAIRSTYLE OR A MAKEUP LOOK.
IT'S NOT EVEN ABOUT REDEFINING
A STYLE. IT'S ABOUT A LOOK,
IT'S ABOUT A SIGNATURE.
ULTIMATELY, TO BE ELEGANT IS
TO LOOK NATURAL.

frédéric fekkai

THE MIRROR USUALLY
REFLECTS ONLY THE WAY
OTHERS SEE US...HARDLY
WHAT WE REALLY ARE.

luigi pirandello
1867-1936

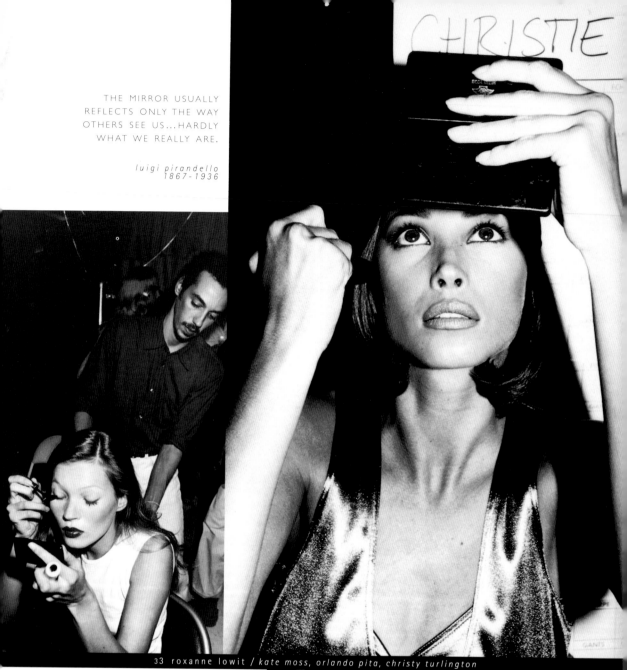

33 roxanne lowit / kate moss, orlando pita, christy turlington

I'M A JUXTAPOSITION OF FLAWS
FROM HEAD TO TOE. YOU CAN'T
CHANGE THAT, SO YOU MAKE
YOUR FLAWS WORK FOR YOU.

iman

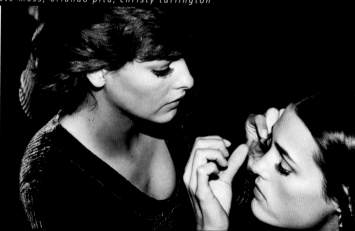

34 roxanne lowit / linda eva...

FEW GIRLS REPRESENT SO WELL
BEAUTY AND STYLE OF THE LATE
90S AS STELLA TENNANT. SHE
IS A TOTALLY MODERN GIRL AND
AT THE SAME TIME HAS A TIMELESS
ELEGANCE AND UNIQUE STYLE.

karl lagerfeld

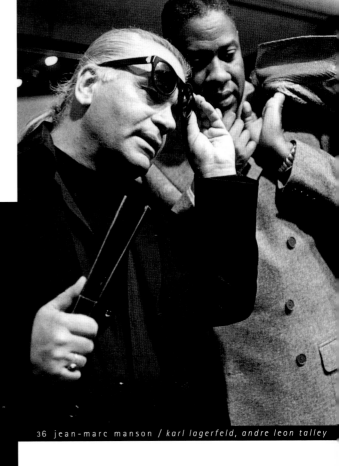

36 jean-marc manson / *karl lagerfeld, andre leon talley*

35 jean-marc manson / *stella tennant*

I'M 25, IT'S AN INTERESTING
ARENA TO BE PLAYING IN. I'M
NOT REALLY DOING MY OWN
THING, AND IT'S REALLY FUNNY TO
BE HAVING THIS PUBLIC LIFE THAT'S
SORT OF BASED ON YOUR LOOKS.

stella tennant

DOING THE SHOWS MAKES ME CRAZY, BUT
THAT'S ALSO WHY I ENJOY DOING THEM. I'M
THE FINAL ARBITER. NO ONE ELSE IS FUSSING
WITH THE GIRLS; I RARELY END UP WITH
SOMEONE RETOUCHED AND REARRANGED.
I ESPECIALLY LOVE DOING HELMUT LANG'S
SHOWS AND CALVIN'S. I'M KNOWN FOR
MINIMAL MAKEUP, BUT THERE ARE TIMES
CALVIN EVEN WANTS LESS THAN I'D DO.
THAT'S EXCITING.

dick page

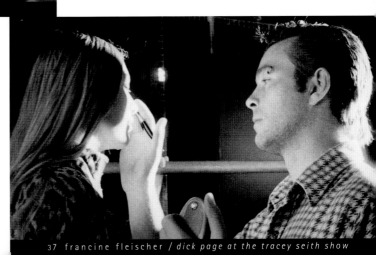

37 francine fleischer / *dick page at the tracey seith show*

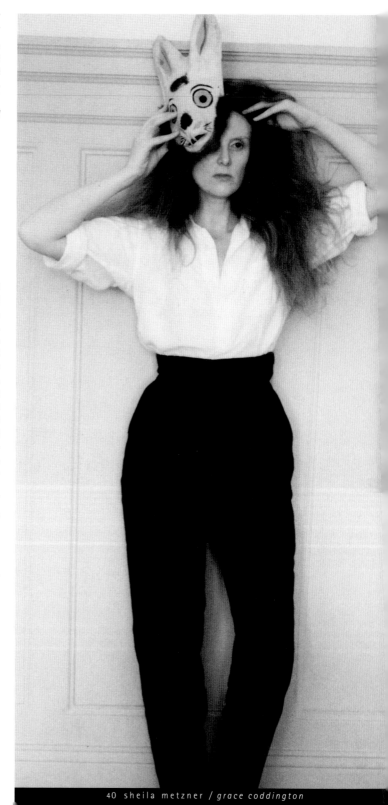

WOMEN NO LONGER WANT
TO BE DICTATED TO ABOUT
CLOTHING OR MAKEUP.
THEY DONT WANT TO
WEAR A MASK. IT HIDES
THEIR IDENTITY.

mary greenwell

THIS PICTURE OF ME IS ONE
SHEILA METZNER SNAPPED WHEN
I WENT TO TALK TO HER ABOUT A
SHOOT WE WERE DOING. AT FIRST,
WHEN I STARTED STYLING, I HAD A
PROBLEM WORKING WITH WOMEN
PHOTOGRAPHERS. IT DATES BACK TO
MY DAYS IN FRONT OF THE CAMERA.
WHEN YOU'RE MODELING, YOU ALWAYS
HAVE A RELATIONSHIP WITH THE
PHOTOGRAPHER. NOT THAT YOU HAVE
TO GO TO BED WITH HIM...BUT THERE
IS SOMETHING SEXUAL ABOUT IT. IT'S
ONE KIND OF RELATIONSHIP IF HE'S
GAY, ANOTHER IF HE'S SEXY AND
STRAIGHT, ANOTHER IF HE'S OLD,
YOUNG, OR IF YOU HATE HIM. BUT
WOMEN? SOMEHOW I JUST NEVER
FELT COMFORTABLE.

BUT IT WAS SHEILA WHO TOLD ME
NOT TO THINK OF HER AS A WOMAN,
BUT AS A PHOTOGRAPHER. SHE PUT
EVERYTHING INTO PERSPECTIVE.
NOW I WORK A GREAT DEAL WITH
ELLEN VON UNWERTH. ONE THING
THAT DRAWS ME TO A PICTURE IS
ELEGANCE AND HUMOR. THAT'S WHY
I LOVE WORKING WITH ELLEN; SHE'LL
TAKE THE MOST ELEGANT GIRL
AND HAVE HER DO SOMETHING
SILLY...AND THE PICTURE WILL
WORK BEAUTIFULLY.

grace coddington

THE PURSUIT OF BEAUTY IS ALL ABOUT HOPE. I ALWAYS LOVED THE PROCESS OF TRANSFORMATION.

linda wells

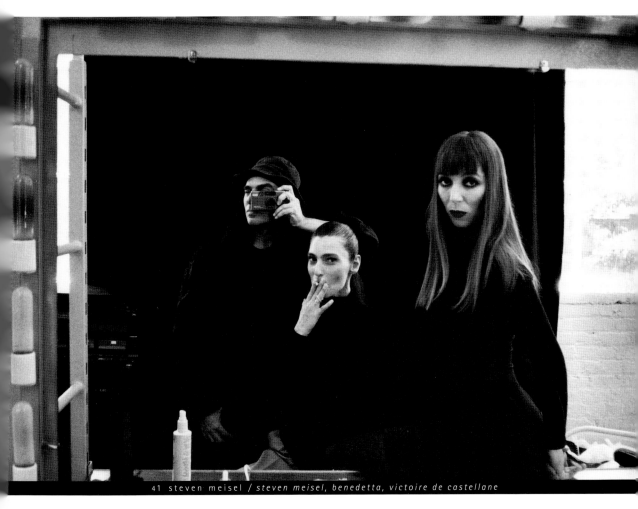

41 steven meisel / *steven meisel, benedetta, victoire de castellane*

HEROIN CHIC IS MORE A POLITICAL
STATEMENT THAN A FASHION STATEMENT.
IT'S ABOUT THE ABILITY OF PEOPLE TO
BE BEAUTIFUL EVEN IN DESPERATE
CIRCUMSTANCES. IT'S AN INTERESTING
IDEA THAT DOESN'T ALWAYS TRANSLATE
WELL TO THE PAGE. WHILE WE'RE
GLAMORIZING THE FAUX DESPERATION
OF HEROIN CHIC, I HOPE NONE OF US
FORGETS THE MANY, MANY PEOPLE
WHO DID SUFFER AND WHO MADE THIS
BUSINESS GREAT, WE'VE LOST SO MANY
OF OUR BEST TO AIDS.

didier malige

thank you

THIS
BOOK *would not have been possible without the cooperation of the photographers who contributed to this project and the many people who work "behind the scenes."*

Nan Bush, Samantha Schmidt, J.J., Maria Markus, Lawrence Harris, Brian Hetherington, Michael Stratton, Mark McKenna, Jennifer Dynof, Candy Singer, Gal Harpaz, Alexandra Morrill, Marion Tande, Eric Pfrunder, Sophie de Langlade, Michelle O'Compo, Lynne De Wardener, Chandra Kelemen, Jung Choi, Steve Sutton, Patrice Lerat-Nagel, Jeff Sowards, Sarah Thomson, Derrick Miller, Mette, Jovanna Papadakis, Dennis Minke, Jill E. Barrett, Michael Margulies, Kristen Ingersoll, Catherine von Ruden, Michele Schiavone, Jim Johnson, Carlos Taylor, Laura Hughes, Mark Edie, Kasey Picayo, Jamie Cabreza ,Wendell, Manuela Galli, Claudia Giampieri, Laurie Wood, Pamela Strahl Terence Falk, Luis Nunez, Patrick O'Leary COLOR EDGE, NYC RAJA, MARK MARKHEIM, PRINT ZONE INC., DEEPAK DATTA, CHRIS BISHOP, DIGITAL IMAGING by Shoot Digital (Judson Baker), ART DEPT.: Jordan Shipenburg, STOCKLAND MARTEL: Maureen Martel, Mary Healy JUDY CASEY, INC., VISAGES: Rhea Rachevsky ART PARTNER: Giovanni Testino MAREK & ASSOCIATES, MARION DE BEAUPRE PRODUCTIONS: Vincent Simonet YANNICK MORISOT: Srenica Munthree JODI RAPPAPORT ARTISTS REPRESENTATIVE, KATY BARKER AGENCY, OUTLINE: Jim Roehrig EDGE: Cynthia Hubler TODD SHEMARYA: Shelley Carter CAMILLA LOWTHER MANAGEMENT, BRYAN BANTRY, ART & COMMERCE, JANET BOTAISH GROUP, M.A.P. PRODUCTIONS, DANIEL ROEBUCK, ELITE NY, IMG: Ivan Bart, Jan Planit FORD MODELS, WOMEN AGENCY, STEPHANIE GIBBS, WILHELMINA WEST COMPANY, BOSS: Glena Marshall DENNIS DAVIDSON ASSOCIATES: Mark Urman, Jennifer Morgerman WOLF KASTELER, ELIZABETH ARDEN: Susan Arnot Heaney NANCY SELTZER & ASSOCIATES: Marcel Pariseau PMK, VINCENT LONGO: Donald Nino M.A.C COSMETICS: Joanne Lupus FRÉDÉRIC FEKKAI BEAUTÉ: Sydney Goldman RMF, INC., Catherine Mahe, EURO RSCG, JAN SHARKANSKY, ROBERT TRIEFUS, SHEILA HEWETT, PHYLLIS POSNICK, DAN MORIARTY, ALISON MAZZOLA, ANNIE ARMSTRONG, PAT BEH WERBLIN, LIBBY HAAN, DONNA BENDER, SUZANNE HODGART, LYNN HUGHES, JUDY SLATER, DEBORAH RITTER-BERGER, CARINA CESARI, HARPER'S BAZAAR: Karen Johnston, Lauren Purcell, Jennifer Preuss PLAYBOY, ELLE, GERMAN VOGUE, THE WORKBOOK, MIRABELLA: Nell Casey LE BOOK

beautycares/haircares

This is a book about beauty, but its ultimate purpose is to help eradicate one of the ugliest problems of the twentieth century: AIDS. Not the disease itself—there is no promise of a vaccine on the horizon, no cure—but rather the prejudice and penury that can go along with it.

Seven years ago, New York hairstylist Marc Pipino came to the inescapable conclusion that not only were many friends and colleagues in the beauty industry dying, they were dying with little comfort, because their funds had been exhausted in the struggle for life. Marc asked four other leading hair professionals to join him in forming an organization now known as BEAUTYCARES/HAIRCARES, which would raise money and give grants to those in the business who were suffering with HIV.

Recently, the organization has become particularly concerned with the alarming rise of women struck with the virus. This is hardly surprising: National statistics show that women constitute the fastest growing group of people with HIV/AIDS in the United States, and that as of October 1993, AIDS was the fourth leading killer of women 25-44 years of age. Notes Leslie Wolfe, president of the Washington, D.C. Center for Women's Policy Studies. "Today, there's still a sense of shame connected to AIDS—as there once was with breast cancer. This must change." Of course, this sense of shame is still pervasive among men and women. Yet AIDS is not a sin—it's an illness.

What is Beauty? may not change people's minds about HIV, but at least it can help to raise awareness—awareness that with all of the public and private money being spent to find a cure, there are still thousands of people dying without the basic comfort that gives us dignity and, perhaps, strength.

Proceeds from sales of *What Is Beauty?* will be donated to BEAUTYCARES/HAIRCARES.

judith newman

Illustration / *Claudia Pearson*

copyright & credits

COVER/PROLOGUE

HAIR/MAKEUP BOB RECINE, SEAN MCCARTHY STYLING MARION MEYER DRESS LIZA BRUCE

12 HAIR/MAKEUP ORIBE, PAUL STARR CLOTHES DOLCE AND GABBANA 17 STYLING KURT BUTLER

18 QUOTE NANCY ETCOFF *NEWSWEEK* HAIR/MAKEUP ODILE GILBERT/STEPHANE MARAIS

INNOCENCE

23 HAIR/MAKEUP CEMAL, LUCIENNE BOTH FOR CLOUTIER STYLING JONATHAN SKOW

27 HAIR/MAKEUP ODILE GILBERT, LINDA CANTELLO COURTESY OF *STERN* MAGAZINE

28 HAIR/MAKEUP MARC LOPEZ, TOPOLINO

30 HAIR/MAKEUP EUGENE SOULIEMEN, PAT MCGRATH COURTESY OF *W* MAGAZINE APRIL 1996

33 QUOTE GIORGIO ARMANI *W* MAGAZINE HAIR/MAKEUP BRETT JACKSON, SARAH LAIRD

LUST

37 ©1995 RICHARD AVEDON HAIR/MAKEUP YANNIK D'IS, FRANCOIS NARS 39 HAIR THOM PRIANO FOR GARREN

40 QUOTE BARBARA HENDRICKS *PEOPLE* MAGAZINE HAIR/MAKEUP DANILO, GIANA FOR MAKEUP FOREVER

MANICURE OLGA TITOVA FOR ORIBE QUOTE NANCY ETCOFF *NEWSWEEK* PHOTO COURTESY OF *GLAMOUR*

42 QUOTE MARTHA GRAHAM *THE NEW YORK TIMES* MAKEUP JAMES KALIARDOS

43 QUOTE RAQUEL WELCH *INTERVIEW* MAGAZINE HAIR/MAKEUP WARD, FULVIA 44 MAKEUP SCOT ANDREW

ARTIFICE

51 MAKEUP SANDRINE VAN SLEE

52 HAIR/MAKEUP ROBERTO PAGNINI, ALESSANDRA CASONI STYLING MARTINE DE MENTHON

53 HAIR/MAKEUP CHARLES LORD, CINDY JOSEPH FOR JEAN OWEN STYLING CLAUDIA LEBENTHAL

55 QUOTE ANJELICA HUSTON *INTERVIEW* MAGAZINE HAIR/MAKEUP FREDERICK PARNELL, ANGIE PARKER

COURTESY OF *INTERVIEW* MAGAZINE 56 QUOTE JODIE FOSTER *PEOPLE* MAGAZINE MAKEUP DANIEL HOWELL

58 © SERGE LUTENS SHISEIDO COSMETICS CAMPAIGN 59 MAKEUP MATHU ANDERSON

GRACE

65 MAKEUP HELEN BARNES 67 STYLING RAQUEL VIDAL

69 QUOTE BETTY FRIEDAN *THE FOUNTAIN OF YOUTH*, JODIE FOSTER *PEOPLE* MAGAZINE

70 MAKEUP REGINA HARRIS 71 HAIR/MAKEUP GUY LAURENT, BILLY B. STYLING LAURA FERRARA

72 QUOTE KARL LAGERFELD THE *NEW YORK TIMES MAGAZINE*,

NAOMI WOLF *NEWSWEEK* MAKEUP ANTONELLA REYNER

ICONS

©1996 BY MICHAEL GROSS. REPRINTED BY PERMISSION OF ELLEN LEVINE LITERARY AGENCY, INC.

82 MAKEUP JOZEF COLLECTION MATSUDA, SPRING 1993

83 QUOTE CAMILLE PAGLIA *SEXUAL PERSONAE*, NANCY ETCOFF *PEOPLE* MAGAZINE

84 HAIR/MAKEUP GARREN, KEVYN AUCOIN 45 COURTESY OF FRENCH *MAX*

87 HAIR/MAKEUP CHRIS MCMILLAN FOR PROFILE AGENCY, MARIE JOSE FOR BRYAN BANTRY

89 QUOTE ELIZABETH HURLEY *INTERVIEW* MAGAZINE HAIR/MAKEUP WARD FOR BRYAN BANTRY, JOANNE GAIR FOR CLOUTIER

90 QUOTE MONIQUE PILLARD *MARIE CLAIRE*

91 QUOTE ERIC BOGOSIAN *ALLURE* HAIR/MAKEUP ODILE GILBERT, HEIDI MORAWETZ FOR CHANEL

93 HAIR/MAKEUP THOM PRIANO FOR GARREN, FULVIA FAROLFI COURTESY OF *HARPER'S BAZAAR*

EDGE

96 HAIR/MAKEUP YANNIK D'IS, LINDA CANTELLO PHOTO COURTESY OF *HARPER'S BAZAAR*

97 GROOMING ANTHONY ISAMBERT STYLING REZA

98 HAIR/MAKEUP GUIDO PAULO, DICK PAGE COURTESY OF *ALLURE*

99 QUOTE TOM FORD *W* MAGAZINE HAIR/MAKEUP DANILO, MATHU ANDERSON MANICURE BERNADETTE

100 HAIR/MAKEUP DIDIER MALIGE, FRAN COOPER 104 MAKEUP PACO BLANCAS 105 HAIR/MAKEUP CEMAL, YASUO

106 QUOTE JEAN-PAUL GAULTIER *ELLE* MAKEUP FRANCISCO VALESA STYLING EDWARD ENIN

107 MAKEUP JOANNE GAIR FOR CLOUTIER/MAKEUP FOREVER

109 HAIR/MAKEUP BOB RECINE FOR JAM, SCOTT ANDREW FOR JED ROOT STYLING VICTORIA BARTLET

110 HAIR/MAKEUP BOB RECINE, SEAN MCCARTHY STYLING MARION MEYER DRESS LIZA BRUCE

WISDOM

114 QUOTE ELIZABETH TAYLOR *PEOPLE* MAGAZINE MAKEUP PAT MCGRATH COURTESY OF *HARPER'S BAZAAR*

116 QUOTE IMAN *PEOPLE* MAGAZINE

121 QUOTE PAULINA PORIZKOVA *HARPER'S BAZAAR*, DONATELLA VERSACE *ALLURE*

126 HAIR/MAKEUP KEVIN RYAN, LISA STOREY BOTH FOR VISAGES STYLE LA

MANICURE ESTELLA FOR NAIL ART COURTESY OF *THE FACE* 1994

127 QUOTE GLORIA STEINEM *REVOLUTION FROM WITHIN*, MELVIN KONNER *NEWSWEEK*

SCENES

01-05 MAKEUP STEPHANE MARAIS 16 MAKEUP ETALO 14,15 HAIR/MAKEUP JUILIEN D'YS, STEPHANE MARAIS

16 HAIR WARD 17 MAKEUP STEPHANE MARAIS 18 HAIR/MAKEUP ODILE GILBERT, STEPHANE MARAIS

19 HAIR/MAKEUP WARD, PABLO M. 27 HAIR/MAKEUP JUILIEN D'YS, STEPHANE MARAIS

YOU
DON'T
THINK something is beautiful until it starts to go
away. A rose is a rose is a rose until you see it fade. Summer is all
beach traffic and heat until you feel the first chill of fall. He is
not the new god of your affections until he turns to leave,
heading for the blue moon on which, no doubt, he came.

And these notions about beauty, that beauty results from your
loss and your desire? Nothing new, nothing new at all. You forget,
and then you remember, and call it beauty.

I mean, how beautiful are our missed friends now, tumbling
in memory like fine pictures we cannot salvage from the
century's greatest fire yet?

BEAUTY REQUIRES DETERMINATION...AND FLEXIBILITY.
LINDA EVANGELISTA CHANGES MORE THAN THE COLOR OF HER HAIR.
YEAR AFTER YEAR, SHE HAS MANAGED TO REINVENT HERSELF AS THIS YEAR'S MODEL.

anna wintour

153 steven meisel / kevyn aucoin, linda evangelista